HAUNTED
SALT LAKE CITY

LAURIE ALLEN, CASSIE ASHTON, KRISTEN CLAY & NANNETTE WATTS

Haunted America

Published by Haunted America
A Division of The History Press
Charleston, SC
www.historypress.com

Front cover: City and County Building, 2018.
Back cover: Salt Lake City skyline, 2013.
Back cover, inset: B'Nai Israel Cemetery, 2010.
Opposite: A view of Salt Lake Valley with the Utah State Capitol Building. *All cover photos and opposite Nannette Watts.*

First published 2018

Manufactured in the United States

ISBN 9781467138246

Library of Congress Control Number: 2018942442

To my mother, who taught me that ghosts are people too.—L.A.

To my husband and children, who never seem to tire of listening to my stories.—C.A.

To my family, both living and dead, of whose stories I am a part.—K.C.

To my parents, thank you for giving me the courage to learn and tell these stories.—N.J.G.W.

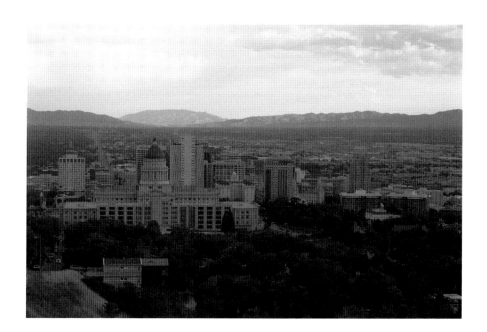

CONTENTS

Foreword, by Martin Tanner 7
Preface 9
Acknowledgements 11
Introduction 13

1. The Alta Club, by Cassie Ashton 17
2. The Andrus Half Way House, by Nannette Watts 24
3. City and County Building, by Cassie Ashton 33
4. Denver Rio Grande Depot, by Kristen Clay 44
5. Devereaux Mansion, by Laurie Allen 53
6. Fort Douglas, by Kristen Clay 60
7. Inn on the Hill: Woodruff Mansion, by Nannette Watts 69
8. The Kissing Tree, by Cassie Ashton 78
9. Masonic Temple, by Nannette Watts 87
10. McCune Mansion, by Cassie Ashton 97
11. Salt Lake City Cemetery, by Kristen Clay 107
12. Sisters of the Holy Cross Hospital, by Nannette Watts 119
13. Whiskey Street Cocktails and Dining, by Kristen Clay 127

Bibliography 135
About the Authors 141

FOREWORD

The ghost stories composing this collection are some of the best of the genre in the Salt Lake City, Utah area. Settled in 1847, Salt Lake City now has a rich history of over 170 years of ghost stories from which the authors draw. The authors have rare talent and vast experience. Cassie Ashton, Laurie Allen, Kristen Clay and Nannette Watts have more than one hundred years of combined professional storytelling experience in a good portion of the United States and internationally as far away as Pakistan. I have seen them delight and captivate their audiences, telling the stories in this volume and others. By now, although no official tally has been kept, they have undoubtedly told stories to well in excess of 100,000 listeners at storytelling events over the years.

Belief in the afterlife, that the dead live on in the form of spirits or ghosts, is found in every culture in the world. Ghost stories fascinate us because we believe they are true or might be. Although often meant to be scary, ghost stories often have other purposes. Some are comedic. Others convey moral principles. Whatever the purpose, the best ghost stories do not rely on violence, blood or gore. They rely on our fear of what comes next—and what comes next in the best ghost stories is supernatural or unexplainable. In ordinary life, we hear, understand and explain. We can't completely understand or explain a ghost story. No matter how many times we read or hear the story, the best part of it remains unexplainable, a mystery.

Ghost stories often evoke a sense of dread. But when they are over, we go back to our regular, comfortable lives. They help us imagine, maybe

even feel a rush of fear, so that we realize how nice and underappreciated our ordinary lives are. This is the crux of why we love ghost stories. We experience the excitement of being drawn into something unsettling, even frightening, rarely felt in ordinary life. But when the story is over, we can safely leave the fear and dread behind, because, after all, it's someone else's experience, and we are not really part of it.

Most people are inquisitive by nature. We like to learn new things, to understand experiences, to solve problems. Mysteries intrigue us because they are something new but not fully understood, a problem not solved. Another reason ghost stories appeal to us is they are a very special kind of mystery. By their nature, ghost stories are about people. They feel intensely personal, because, after all, we, too, could have such an experience. They are about the afterlife and its connection with this life and with us. And like all mysteries, they have an element of the unknown. These are some of the reasons why this collection of ghost stories is so wonderful and will appeal to so many.

MARTIN TANNER
Chair, the International Association for Near-death Studies, Utah Chapter
Host of the *Religion Today Show* on KSL Radio, Salt Lake City, Utah

PREFACE

There were ghosts in Salt Lake City. Kristen Clay could just feel it. She learned ghost legends and lore in the Hawaiian Islands. Upon her return to Utah, she would look at historical buildings and wonder at their rich heritage and was certain ghosts were there. She interviewed people who inhabited the buildings to find the unseen spirits.

In 2002, she had collected enough first- and secondhand accounts of hauntings to start Utah's first ghost tour company, Story Tours: Salt Lake City Ghost Tours. She hired buses and held auditions for storytellers to help her share the legends of SLC. Tours took guests to the haunted reaches of downtown Salt Lake, with story guides sharing the legends and lore Kristen had uncovered. The next year, she added Ogden ghost stories to the repertoire.

The story vault expanded, and more sites were added to the tour. Story Tours was alternating routes and creating different tours within four years. In three more years, there were enough stories for two different routes with early and later shows. Patrons could enjoy ghost stories for more than three hours. Ten years after Kristen started Ogden and SLC Ghost Tours, other companies began to pop up, eerily sharing the same exact stories. There is a famous quote: "Imitation is the sincerest form of flattery." Story Tours continued strong and allowed others to coexist.

On the first page of the script, we explain to our guests that we are not ghost hunters or even ghost aficionados. We are storytellers. Many who came on tours were ghost lovers and began sharing their experiences with us,

especially when connected to one of the buildings on the tour. We grabbed paper and made notes. We often wrote down first names, but some people were not interested in sharing their surnames. The script grew organically. We hope you see yourself and your story in these pages.

This project, like many projects, has had a life of its own. There have been ups and downs with twists and turns. With thoughts of a book, some guides were given advice to self-publish. We assigned stories and went to work. Self-publishing has real challenges, and the project came to a standstill. The History Press approached Kristen about publishing some of the many stories her storytellers were telling. She took the proposal to the other authors, and most of them supported her. An answer to our publishing dilemma was found. We appreciate the support and guidance of our publisher. We are thrilled to share our version of the Salt Lake City ghost stories we have been telling for now over fifteen years. We hope you will enjoy them as much as we do.

If you are ever in Salt Lake City, come enjoy the stories in person and see the beautiful buildings that host a variety of colorful ghosts. You can reach us at www.storytours.com and schedule a tour with Story Tours for the Ogden and Salt Lake City Ghost Tours.

ACKNOWLEDGEMENTS

This book has been an exciting adventure for myself and our team. It has indeed been a community effort. There are many who deserve a thank-you, including *all* the Story Tours: Ogden and Salt Lake City Ghost Tour story guides who, throughout the years, have performed with skill, collected stories and shared these ghostly tales and experiences, including administrative assistant Becky Nalder, who climbed out of her shell to become the left brain of the organization, kept track of every detail and big-heartedly helped us shine.

A special shout-out goes to Nannette Watts, who has generously taken on the lion's share of handling the technical aspect of putting this book together, from her eye-catching photographs to collecting and organizing the images and manuscripts and formatting them together. Your sleepless nights, ground-down teeth and sacrificed time have not gone unappreciated. And thank you to Laurie Allen for her sense of humor and eagle eye in spotting the smallest letter out of place and to Cassie Ashton for her amazing ability to get to the heart of the real story and to make it make sense. I am infinitely grateful for the constant encouragement, diligence, intriguing interviews, meticulous research and splendid storytelling of this team: Laurie Allen, Cassie Ashton and Nannette Watts.

Thank you to Rosemarie Howard, at Dramatic Dimensions, who shared her wisdom, know-how and writing skills in the early phases of this project. Recognition also goes to our family members and friends who have tirelessly read and reread our many drafts—to the point they may now see ghosts in their sleep.

Thanks to our editors at The History Press, Artie Crisp, Candice Lawrence and Hilary Parrish, as well as the talented design team.

Kudos to the many residents of Salt Lake City, past and present, living and dead, who have shared their ghost stories and lore!

Hauntingly Yours,
Kristen Clay

INTRODUCTION

Our intention in sharing these ghost stories is to expand your imagination and present you with fun, rich images and maybe create a chill or two, but not to terrify. We do not attempt to prove the existence of ghosts or try to explain the paranormal; we will share what others have experienced, and you can decide whether to believe or not.

These stories are first- or secondhand accounts from those who have encountered something out of the ordinary that could only be explained by accepting the potential of an unseen world. We offer these stories as a doorway to new possibilities. Some say these stories give them permission to accept what they thought was farfetched. They are reassured to know that things happen in the invisible world. We are thrilled to the bones when someone hears one of our ghost stories, remembers their own story and walks away sharing that with others. We hope that will be you.

What surprised us was in the process of telling, gathering and researching these stories, we came to know the history of the area. We slowly became Salt Lake City history buffs. Sadly, there is not enough room to include all the stories we have gathered, so we are sharing our favorites until we have the opportunity to publish our other favorites.

In this book, you will meet Mormon pioneers, members of the Church of Jesus Christ of Latter-day Saints (often referred to as Mormons or LDS) who were fleeing persecution. Led by their president and prophet, Brigham Young, they crossed the plains and came over the Rocky Mountains seeking refuge. They found a place to practice religious freedom, but their solitude lasted only a decade.

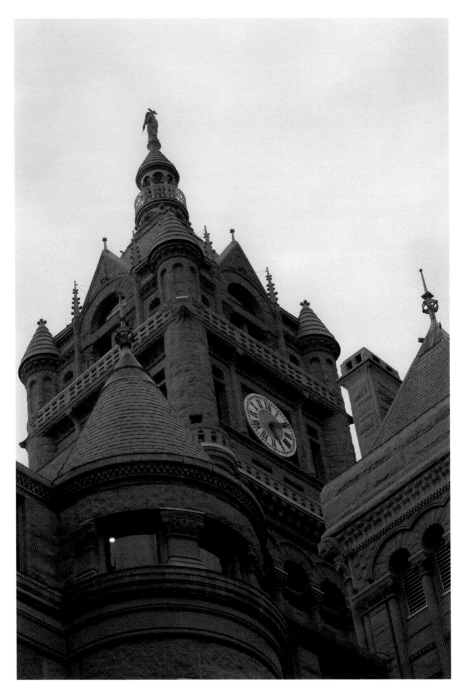

City and County Building clock tower spires, 2018. *Nannette Watts.*

You will meet masons, miners and railroad workers who encroached on the close-knit community. Conflict and misunderstandings between the "Mormons" and the "Gentiles" (those not belonging to the LDS Church) arose, creating some colorful encounters amidst beautiful buildings. You will also meet political rivals who still stare each other down and the first female U.S. senator, who is still serving her beloved state. You will meet nuns who became nurses and a husband who nursed his wife, all of whom continue to nurture those left behind.

There is mystery, murder, mischief and romance woven within these stories. Join us for an entrancing journey from Utah's past into the present to get acquainted with those who love to linger in the Salt Lake Valley. You will discover *this is the place* where the Saints and Sinners go marching on again and again and…well, you get the picture.

CHAPTER 1

THE ALTA CLUB

100 East South Temple

BY CASSIE ASHTON

S alt Lake City's Grand Boulevard," once known as Brigham Street and now known as South Temple, was the street where governors, senators, silver kings and a queen, religious leaders, financiers and the business elite built their homes. In the early days of Utah, the vast majority of Utah's wealth resided along this most opulent thoroughfare. At the head of this east–west boulevard stands the Alta Club.

The Alta Club, originally open to men only, was first established in 1883. There is a bit of a debate as to how its name was derived. Some say it came as a way to honor those who struck it rich from silver mining up Little Cottonwood Canyon in Alta, Utah. Others say that name came from its first home in the Alta Block of Salt Lake City. Either way, the name has lasted.

The first home for the Alta Club was in the old Alta Block, located at 21 West 200 South in downtown Salt Lake. In 1892, it moved down the street to 109 West 200 South in the Dooly Building, where it occupied the top two floors. In 1897, a lot was purchased by the club members around the corner from the Dooly Building to construct a permanent building. It took a year to build, and on June 1, 1898, they moved into the home they have been in for over one hundred years. It was designed by Fredrick Albert Hale in an Italian Renaissance design. It was built by George Cushing and is in the National Register of Historic Places.

In the early days, the members were primarily the elite in the mining and smelting industry who struck it rich mining in Utah and then went on to run newspapers and large businesses and become bankers or politicians.

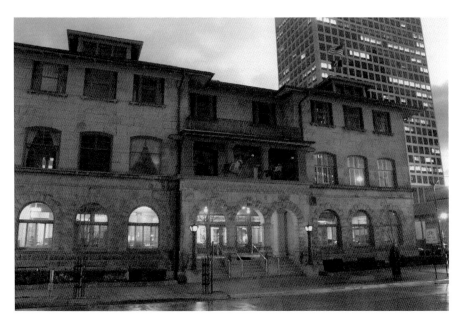

Present-day Alta Club. *Nannette Watts.*

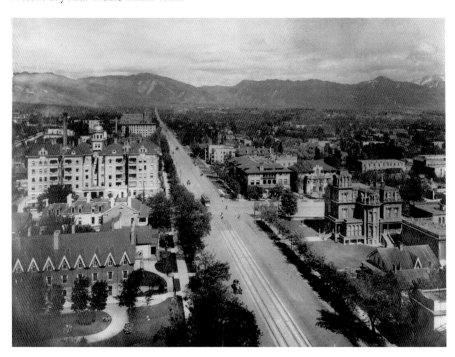

Brigham Street, Salt Lake's Grand Boulevard, South Temple, 1908. The Alta Club is on the southeast corner where the street intersects. *Marriott Library.*

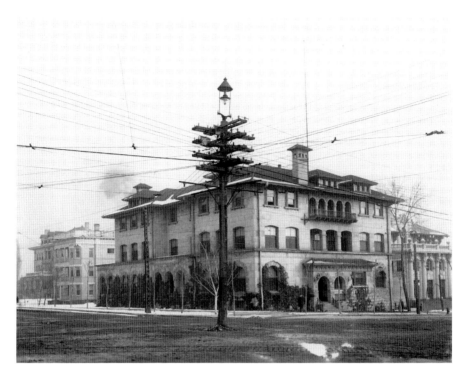

Alta Club, 1905. *Marriott Library.*

The club was created not for those who came out west to be with the Saints but for those who came out to get rich and still wanted to enjoy what the Saints did not: drinking, smoking and gambling. It was and still is a private club, for members only. In the beginning, it was primarily a non-Mormon club. Eventually, the membership would expand to allow a huge diversity of leaders, and they would all learn to find ways to cooperate and appreciate their differences. Those differences ranged from religious to political to the unseen. One thing you can be sure of is the Alta Club staff are very protective of their members and their secrets, including their ghosts. Sometimes the best way to gather information is to talk to those indirectly connected to the old historic building.

LILAC GHOSTS

A ball went flying through the air, followed by a distinctive *crash*. Jed and Adam looked at each other and then at the mug lying beside their ball on the living room floor. Should they run?

"Boys, what are you two doing?" their mom called. Their mother's voice and quick appearance in the living room doorway made the decision for them.

"How many times have I told you two not to play ball in the house?" she asked.

The two boys looked at the floor, avoiding their mother's eyes.

"You are lucky that this mug is not broken into pieces," their mom said, "or your dad would have killed you both. This was your great-uncle Pete's Alta Club mug. I don't really need your father to be angry or want my boys to join the ghosts of the Alta Club."

"Mom, did you say there are ghosts at the Alta Club?" young Jed asked, thankful for a way to change the subject. "Are there really?"

"Yes. Well, at least according to Uncle Pete," his mom replied.

"What happens?" Jed wanted to know. "Who are they? Can we go see them?"

"Slow down, my little ghostbusters," their mom said. "Why don't you hold all those questions for your dad? He is the one who heard about all the goings-on and activities at the club."

"Mom, just tell us," Jed begged.

"Wait 'til your dad comes home," their mom insisted.

The boys were so excited for their dad to get home. Almost as soon as he walked through the door, they began badgering him with questions about the ghosts at the Alta Club.

A little confused, he held up his hands in self-defense.

"Whoa, whoa, whoa!" he exclaimed. "Where did all this come from?"

"We were playing ball in the house, and Adam knocked over your Alta Club mug. Mom got mad and said if we broke it you would kill us and we would be ghosts at the club," Jed answered.

Their dad began to laugh.

"Well, I may not have killed you," he chuckled, "but I would have been pretty disappointed. Your great-uncle Pete gave that to me, and it holds some good memories—all the stories he told and laughs we shared."

"Yea, yea, but what about the ghosts?" Jed wanted to know.

"Calm down, son," their dad said. "We will get there. Sit down and I will tell you all about your great-uncle Pete and the 'Boy Scouts' of the Alta Club and, of course, about the ghosts."

"There were Boy Scouts at the Alta Club?" Adam asked, looking puzzled.

"No, no. Not like you boys are Scouts," said his dad. "You see, in the mid-1930s, your great-uncle Pete was a young successful businessman, and a group of men about his age were encouraged to join the Alta Club by the older members. It was in an effort to bring some new, young blood into the club. The younger men were soon being referred to as the 'Boy Scouts,' probably because of their comparative youthfulness and partially because they could be a bit loud and rambunctious. Uncle Pete told me that the Boy Scouts gathered regularly at the club for lunch. The manager offered them a bit of privacy by assigning them to a room known as the 'Bird Cage,' a smaller dining room at the end of the main dining room that had Chinese bird decorations in the wallpaper. Though they were separated from the main dining hall, the complaints about their loudness caused the manager to move the Boy Scouts to a card room adjoining the bar on the lower level. There, they could order sandwiches, relax and make a bit of noise without annoying the club elders. The funny thing is it wasn't long before the elders noticed the arrangement. They liked it and started joining the younger men. That is how the Grill Room was started. Uncle Pete kind of boasted that the Grill Room was created by the Boy Scouts."

"Cool, Dad," Adam said. "Uncle Pete was an Alta Club Boy Scout, but what about the ghosts?"

"Okay, okay, I'm getting there," replied his dad, "but first I wanted you to get a picture of what it was like back then.

"The first story I remember Uncle Pete telling me was in the early days of the club. He said that there were always jokes throughout Salt Lake about it being an 'old man's club' and how they would discover bodies around the premises. He always thought they were just joking about the old guys being so stiff and quiet, but that wasn't the case. Uncle Pete soon discovered a rumor that a prominent citizen had gone missing, and after a weeklong search, the police finally reported the man had been found dead in his favorite leather chair in the Alta Club. Pete said he never knew how true the story was because nobody talked about it. He did admit that whenever he was in the library, it always felt a bit creepy, and occasionally, one of the wicker rocking chairs would rock all by itself."

"Do you think the dead guy hangs out at the library?" Jed asked.

"Maybe," his father replied. "It makes sense to me. The other story I remember Uncle Pete told me about happened years later. Sometime in the 1950s, the club had a fire. At the time, there were rooms upstairs that some of the members could stay in for a night or two.

Alta Club's leather reading chairs. *Marriott Library.*

"One night after a long night of work, an exhausted club member retired to his room and was winding down by enjoying an expensive cigar. I guess he did not realize how tired he was, and he fell asleep with the cigar in his hand. The cigar fell to the ground, and the rug caught on fire. His room was quickly engulfed in flames. Everyone else was able to escape the fire except for him. They say that he still walks the upper floors checking the rooms to make sure that no one else falls asleep smoking."

"Did Uncle Pete ever say who he was?" Adam asked.

"No," his dad replied. "Like you, I was curious. But when I asked Uncle Pete, all he would say was, 'He paid the price of his carelessness with his life. Let's let him rest in peace.'

"I actually tried to learn a little more about the fire. Although I searched and searched, I could find no record of it in the newspaper or the Alta Club histories. Club members guard their secrets well."

"Does anything else happen?" Adam asked.

"Not much," his dad replied. "I have heard that sometimes members will feel someone touch them on their shoulders. They turn, but no one is there. It doesn't seem to bother anyone; they shrug and figure it is just a deceased member letting them know they are still hanging out around the club. There is also the sound of footsteps pacing back and forth on the third floor. Even though smoking is no longer allowed in the rooms, the cigar-smoking ghost is taking no chances."

"That's creepy," Jed said. "Have you ever been to the Alta Club?"

"Yes, Uncle Pete took me in a couple of times when he had to stop in and pick something up," their dad said. "I've only been in the lobby. It's very beautiful—elegant with rich wood and big leather chairs."

"Did you see the ghost or feel a ghost?" Adam asked.

"No, but it did seem to smell like lilac," their dad responded. "I thought that was strange because even though there are women who are members now, it is still a traditional gentleman's club, not a place you expect to smell lilac flowers. But ghost lore says that when you smell lilac and lavender in a building, there is probably a ghost nearby."

"Dad, can you take us someday, and maybe we can see or smell the ghost?" the boys asked.

"Well, boys," their dad said, "I never became a member. I'd rather spend my nights here with you. When you boys get a bit older and learn how to behave a little bit better, I am sure I can find one of Pete's sons who might let us be his guests. Then maybe you will get to meet a ghost, maybe even Uncle Pete—you know, hanging out having lunch in the Grill Room."

CHAPTER 2

THE ANDRUS HALF WAY HOUSE

This Is the Place Heritage Park, corner of Brigham and Main Streets

BY NANNETTE WATTS

S alt Lake City was in the heart of the Wild West. Famous cowboys and outlaws roamed these parts. Traveling by horse or wagon took longer for travelers. People stayed at family-owned inns. Some inns were only twelve miles apart.

There is a marker at 10450 South State Street in Sandy, called Neff's Grove, that reads:

> *"Half Way House"*
> *Only a few yards from this monument to the Northwest, stood the Milo Andrus "Half Way House," a comfortable and convenient, two-story pioneer inn. The inn was one of several built along State Street in the 1850–80 period to care for the many south and northbound travelers.*
>
> *The Andrus Inn became known as the "Half Way House" because it was located midway between "Traveler's Rest" at 6400 South State and Porter Rockwell's establishment near the Point of the Mountain. If one were walking, riding horseback or in a buggy or their [sic] horse-drawn conveyance, the Andrus place was always a welcome stop.*
>
> *Built in 1859 and the early part of the 1860's, the Half Way House served as both a hotel and a family residence for 120 years. The structure was moved from here beginning in 1980 to the Pioneer Trails State Park in Salt Lake City after its history was authenticated by the State.*

Lucy Loomis Tuttle Andrus was a tough pioneer woman. She was industrious, intelligent and organized. She was born in England in 1822. One year after marrying Hubbard Tuttle in 1843, they joined the Church of Jesus Christ of Latter-day Saints. They decided to move with the Saints to the United States.

Their belongings were sent on a different ship to California and never seen again. While crossing the plains, Lucy suffered from malnutrition, called black scurvy, but they made it to Salt Lake City with their small children.

Hubbard decided to seek gold in California. Lucy thought he actually wanted to locate Lucy's valuables that had disappeared on the voyage from England. Hubbard did not return. He died there of cholera, leaving Lucy behind with three young children. Without her husband, a woman in those days had no property rights.

In 1851, Lucy married Milo Andrus. This union made Lucy Milo's third wife. Milo's first wife decided a little too late that she did not like plural marriage; they divorced two years later. Milo's second wife died the same year he married Lucy, placing Lucy in a leadership position when he wed two more wives the following year.

Milo was a respected pioneer who was quick to help and serve others. Some recorded that Milo had superhuman strength when working for a good cause.

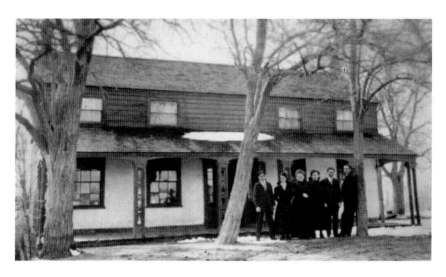

Andrus Half Way House, built and operated by Lucy Andrus from 1860 to 1868. These are possibly Andrus family members. *Marriott Library.*

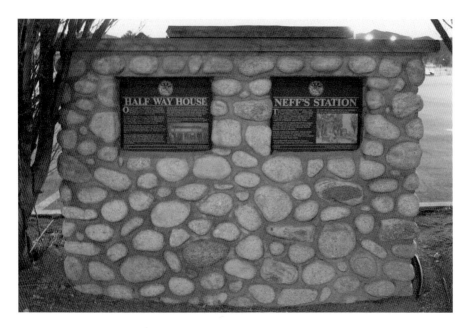

Monument to Andrus Half Way House and Neff's Station, just southeast of Neff's Grove, on State Street in Sandy, Utah. *Nannette Watts.*

He led several wagon trains west, served in various volunteer church positions and went on several ecclesiastical missions, leaving his family in Utah.

The Andrus family decided to build a house that would serve as an inn for weary travelers. They purchased 160 acres in the south end of the Salt Lake Valley, which strategically included land on State Street.

A mission assignment came for Milo to go to England. Lucy was determined that the family needed this home so the inn could help them provide for the family and for Milo's mission. The Andrus Half Way House was built under Lucy's direction. Lucy used a new building method called "balloon framing." This was different from typical construction at the time of large posts, masonry bricks or stacking logs. The introduction of nails and two-inch boards saved time and money. The home included a dry kitchen and large dining room, along with a parlor on the main floor. Three bedrooms were located upstairs.

Three Andrus wives—Lucy, Adeline Alexander and Jane Munday— moved to the inn and fulfilled specific duties. The inn was such an enjoyable place to live that some of Milo's wives decided not to move to southern Utah when he received a call to help settle the area of St. George. Lucy was one who stayed at the inn.

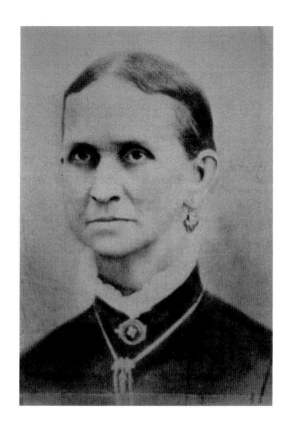

Right: Lucy Loomis Tuttle Andrus. *Courtesy of the Christensen family. Nannette Watts.*

Below: Andrus Halfway House at This Is the Place Heritage Park, 2013. This pioneer park offers a view to the past. *Nannette Watts.*

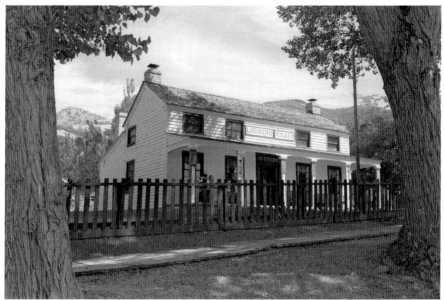

Milo returned from his mission and moved to Idaho to create a new settlement. Lucy was a strong woman making her own way in a man's world. She stayed at the inn and even moved south to create another. It was at the second inn that an incident at the barn caused a stir of rumors. Lucy Tuttle Andrus was dead. No one in the area could believe such a strong woman was gone. The real story seemed embarrassing for such a capable woman, so her family kept quiet about the details. The unknown caused rumors to spread.

Some folks speculated that Milo had asked Porter Rockwell to kill Lucy. The family went berserk with this horrible rumor and tried to repair the damage by telling the truth. Lucy had readied the buggy to go out. As she was leaving the barn, something spooked the horses, the buggy flipped and that accident caused Lucy's death. But truth just could not get in front of the crazy story. No matter the cause, Lucy Loomis Tuttle Andrus was laid to rest—or was she?

Her house was moved in 1980 to This Is the Place Heritage Park in Salt Lake City when the state verified its historical value.

Did You Hear That?

The stars and the moon provided no light and a misty cloud hung in the air as they approached the house. Debbi had agreed to give a private tour of the Halfway House.* She got out her skeleton key, unlocked the front door and let it swing all the way open. The entryway was small, and the stairs leading to the second floor were so close they almost touched the open door.

The members in the five-person group paused as Debbi turned off her flashlight and readied her camera. She pointed it up the staircase, and a series of camera flashes blazed before the eyes of the small group. Debbi reviewed the three shots in the camera's digital viewfinder and quietly sang, "There she is."

The group could not see her, but the camera revealed her place on the stairs. They each crowded around to gaze at her. What they saw was an apparition standing on the stairway almost at the landing—translucent, white and pale, dressed in a straight pioneer dress, carrying a fan in her left hand.

* The Andrus family spelled it Half Way, as two words, and it is spelled that way on monuments and in records. When This Is the Place Park moved the home, it changed the spelling to Halfway House.

In the first photo, it appeared as though she was coming down the stairs to greet those entering her home. In the second photo, she had moved her fan. In the third picture, she had turned her head up to the left, as if she was leaving to go back upstairs or was talking to someone up there.

The group was amazed. One member of the group did not want to enter a house with a ghost standing right on the stairs to greet her. As far as Janene was concerned, the ghost search had been successful. She was content to have come so close to a real haunted house—and from the porch, she found it not so scary.

The moment she started to feel comfortable, the other three adults entered the house. A few nice pictures of a ghost were not enough to coax her in. She gulped and looked at her son for support. She was ready to tell him she would stay out there on the porch with him if he were scared.

The traitor was heading through the door with a huge smile on his face. "Come on, Mom!" he beamed.

She turned and looked down the road as a gust of cold wind blew leaves in circling eddies up the road. Should she stay outside alone, she asked herself, or go inside with people—flesh-and-blood people? She jumped through the door.

As the other guide, David, closed the door behind them, locking them in, Janene fought all of the dark images growing in her imagination. Which was worse, locking out the living or being locked inside a haunted house?

Her love for history saved her. She was fascinated as Debbi and David told them about the inn, a popular stop between Salt Lake City and Provo, run by Lucy Andrus. They showed the other three the dining room to the right of the entry, where Lucy fed visitors. As they walked into the parlor where the talented family entertained guests, David held up a framed shadowbox that contained an ornate weaving.

"They made it by weaving human hair," Debbi said.

"Excuse me?" Janene responded in surprise. They all gasped and took a closer look at the piece of art. They were all amazed by the artistry of the pioneers and their dedication not to waste anything.

"With all the females in this house," Debbi continued, "you can imagine they had plenty of hair to work with. Some family journals say Orrin Porter Rockwell was a frequent visitor to the house, and one of the daughters used to brush and braid his long, dark hair. Some of his hair might be in that very weaving—if it is actually a weaving from the Andrus family."

The guides continued the tour, telling them about the history of the home and what the rooms were used for. Debbi walked them straight through the family dining room to the back of the house and into the kitchen.

"There is always activity in the kitchen," Debbi said. Janene gulped and entered the kitchen—only after Debbi added, "But not tonight."

Janene felt uneasy as Debbi opened the pantry door. "The pantry always has a presence," Debbi said.

Sure enough, the camera picked up some orbs—perhaps two or more. Janene could handle orbs; they were harmless bright light circles in a picture that looked like dust specks. She was just beginning to feel calm when she glanced at her son Caden. He looked sick.

"Do you feel okay?" she asked. He nodded tentatively but then shook his head side-to-side. But they both turned their attention to Debbi as she told them more about the kitchen.

"You'll notice that the ladies didn't have any water in the kitchen. It is called a dry kitchen because they had to go outside to get water.

"There was a wooden bowl that belonged in this kitchen when Lucy lived here. One day, I picked up the bowl and instantly felt as if I shouldn't have touched it. I put it down and looked around.

"'I'm sorry for touching it,' I said out loud.

"At the time I was, and still am, the only person with a key to this house. The next time I entered this house, the bowl was gone and has not been seen since. It has not turned up in this home or in any other home in the village."

As Debbi finished her story, they left the kitchen and moved back into the dining room.

"This is where the family would have enjoyed their meals," Debbi told them. "Notice the wide floorboards. This demonstrates one of the building innovations that Lucy implemented in her day."

At that point, Debbi and the others quickly left the dining room.

While the other three were climbing the stairs, Caden and his mom were still in the middle of the dining room.

"How do you feel?" she asked Caden.

"I felt so sick in there," he responded. "But I was fine as soon as we walked through the dining room door. I don't think little boys were allowed in her kitchen!"

They stopped and looked at each other. From the kitchen behind them, they distinctly heard booted footsteps on the wide wooden boards.

Janene thought she was hearing things, but Caden's wide-eyed, "Do you hear that?" validated her impression.

Before she could answer, they both had the same idea: Let's get out of here!

Janene could hear Caden right on her heels as she outpaced him to the front door. She had the doorknob in her hand when she remembered two things: the front door was locked, and David had the only key.

"Up here!" called Caden as he leapt up the stairs two at a time. She was close behind him as he panted, "I figured she wasn't on the stairs if she was in the kitchen now."

"Good thinking, Caden," she responded breathlessly.

Debbi had continued with the tour and was headed to a back bedroom when they caught up with the other three.

"The camera usually picks up an orb in the corner of this room," she told them, pointing the camera directly above where Janene was standing.

Briskly, Janene moved out of the corner. Fortunately, the usual orb was not there that night.

Whew! she said to herself as they walked out of that room. Straight ahead was another room.

"We will not be going in there," Debbi whispered. "We keep it locked up."

Debbi stood blocking the entrance to the room as she directed them back the way they had come.

With the stair rail on their left and a wall on their right, they walked back down the short, narrow hallway to another room where boarders had stayed.

The five of them took up most of the space in the hallway as they crowded around the doorway trying to see the room and listen to the tour guides. Janene was back far enough that she was almost touching the stair rail behind her.

Suddenly, she could sense someone walking up the stairs. She turned her head but saw no one. She felt sure someone wanted to get past them to move down the hallway where they had just been.

Janene turned to smile at…at…air and moved instinctively backward against the rail. She sucked in her stomach and reached for her son to pull him back—like mothers used to do before cars had seat belts. And let's face it, there is only so much a person can suck in.

It was a very polite exchange. She caught her breath as she felt, or sensed, the presence pass by.

Suddenly, she realized Caden was looking at her with an amused expression on his face. He was wondering why she had pulled him away from the group. She was too stunned to speak. So they both tuned back into the story Debbi was telling.

"How did they fit all of the boarders into that one room?" Caden asked as he eyed the small room.

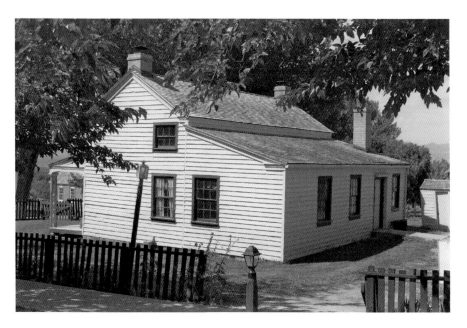

Side and rear view of the Andrus Half Way House. The door to the dry kitchen is visible in rear. Visitors stayed upstairs. *Nannette Watts.*

"The cowboys would pull their bedrolls from the backs of their horses," responded David, enjoying Caden's wonder. "Then they would roll them out one right alongside the other in the little room."

As they prepared to descend the stairway back to the front door, the other guest asked, "Are we okay to go down the stairs? Is Lucy Andrus still in her spot?"

"She is probably not near us," responded Debbi, "but is wandering around her house. She usually moves about when there is so much activity in the home."

The tour ended with no other ghostly sightings.

Lucy Andrus was quite the hostess—very polite and hospitable. Just keep your little boys out of her kitchen.

CHAPTER 3
CITY AND COUNTY BUILDING

451 South State Street

BY CASSIE ASHTON

The City and County Building is built on what is called Washington Square Park. It was originally called Emigration Square because in 1847 it was the spot where many families camped when first entering the valley. It is a ten-acre block between 400 and 500 South State Street and 200 East. The building is unique in many ways, including a labyrinth of underground tunnels that were used to connect the building to the old jail where Salt Lake City's Main Library now stands. It went through a major renovation and repair from 1986 to 1989, but instead of completely replacing the marble tile, each piece was lifted, cleaned and reset. The desire was to maintain its historical accuracy. Maybe that original beauty is not the only thing that was maintained; many believe that spirits are more likely to remain when original furniture, objects or material are present. Since much of the old building is original, it seems to maintain the energy of many of the people who have wandered the halls.

The City and County Building is Utah's best example of Richardsonian Romanesque architecture, which was a very popular style for public buildings during the turn of the century when it was built. It was built by the Freemasons and dedicated in 1893. It is massive, statuesque and richly ornamented. It rises three hundred feet to a bell tower flanked by clocks. The bell tower offers a view of the whole county, from the Oquirrh Mountains on the west to the Wasatch Mountains on the east. It is a treasure, especially here in the West. They do not construct buildings with that kind of detail and craftsmanship any longer. It has so much character

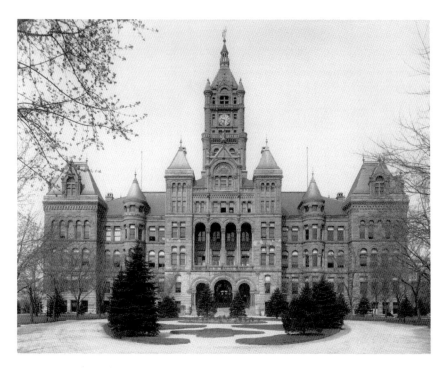

Salt Lake City and County Building, 1905. *Marriott Library.*

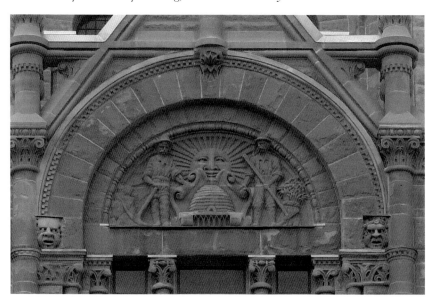

City and County Building sculpting sample depicting Utah scenes: a miner, a farmer, a beehive and a sun stone with gargoyles for protection. *Cassie Ashton.*

all on its own without any supernatural activity. Walk around the outside of the building and see the masterfully crafted symbols and scenes depicting events and themes in Utah's history, carvings of gargoyles, animals, roses and scrolls. They seem to have a story to tell all their own. It was built to rival the LDS Salt Lake Temple, and it does.

The construction of the building was riddled with controversy. It was built as a distinct statement of separation of church and state. Many non-Mormon political officials wanted to make a clear statement that Utah was not run by the Mormon Church. Utah was separate and served all the many people who had flocked to the beautiful city built by Brigham Young and the Mormons. Mayor Robert N. Baskin, who oversaw its building, said it would be "a temple of justice, and in some measure a representation of the majesty of the law. In its superstructure, it will rise above its surroundings. And as it towers above its environment, so will the majesty and dignity of the law, as represented in the municipal, state and national governments, rise above church influence and conditions." It has lived up to its purpose to be inclusive of all those who enter, be they living or dead.

A WALK WITH THE DEAD

Bill, the night security guard at the Salt Lake City and County Building, was thrilled when his boss asked him if he would honor a request from a team of paranormal investigators to spend a few hours in the building one evening.

The paranormal investigators (ghost hunters) had asked permission to conduct an investigation primarily for training purposes. They wanted to test some new equipment and train a new team member. This building was perfect for their project. Ghost hunters were almost guaranteed a paranormal appearance.

The crew consisted of Mitch, the cameraman and boss; Jules, the audio expert; and Natasha, the newbie. They came fully equipped with a new Air Ion Counter, EMF (electromagnetic field) meters, EVP (electronic voice phenomena) digital recorders, still cameras and video cameras, flashlights covered with red film, candles to back up the flashlights, a compass, thermometers, talcum powder and other such devices.

They were ready to capture unknown faces, follow unseen footsteps or hear answers to questions they asked in the dark.

"Bill, your boss mentioned that you actually enjoy the graveyard shift where many others haven't lasted long. What's your secret?" Mitch asked after introductions were made.

"I'd heard the rumors about all kinds of spirits walking the halls," Bill answered, "but that is what intrigued me about this job. I like ghosts. I have always been fascinated with the paranormal possibility. I guess my curiosity keeps me open and on my toes."

"What should we be watching for?" Mitch asked.

"Well, many ghosts are reported to be in the building," Bill said. "There is at least one story for every floor, probably more. But a lot of the stories have gotten mixed up and made up.

"I'll tell you what I have learned and the stories that I think are true. Maybe your equipment will help establish the truth of some of the rumors. Let's head up to the fifth floor."

As they piled into the elevator, Bill asked, "What equipment would you use to see if anyone was in the elevator with us right now?"

"I know! Check the EMF detector," Natasha answered excitedly, pulling it out. "It should show us if there are any electromagnetic fluctuations."

Natasha turned on the EMF detector, and they all looked to see if the needle registered any activity. "Nothing." Mitch asked, "Has something happened before?"

"Oh, yeah," said Bill.

One night, a security guard was doing rounds. He was headed up to the fifth floor when the elevator opened. A distinguished older man exited. They nodded and greeted each other. The man then passed down the hall carrying a cane and wearing an older style of clothes—very formal with top hat and tails.

The guard wasn't surprised by the odd clothing. The city officials often attend galas, fundraisers or special parties that require them to be dressed up, so he was used to seeing someone in period costume. But when the guard looked back for a second glance, no one was there. The old man had vanished. The guard kept thinking that the man looked familiar but couldn't place him.

He mentally went through the offices in the building trying to figure out who had greeted him, but he was drawing a blank. The guard was frustrated. He took pride in knowing who was in the building, especially those who tended to work late.

As he continued doing rounds on the third floor, he passed the portrait of former Salt Lake City mayor R.N. Baskin, who had been mayor when

The portrait of R.N. Baskin hanging outside the mayor's office. *Cassie Ashton.*

the building was built. When he glanced at the portrait, the guard gave a double-take. He stopped and stared at it. Suddenly, it hit him! He was looking at the man who had greeted him at the elevator—the ghost of long-deceased R.N. Baskin. The gossip was true; Mayor Baskin roams the halls watching over his beloved building.

Natasha asked, "Bill, have you ever seen the mayor?"

Bill smiled and shrugged. "Let's just say this is an active building. I would suggest taking pictures of Mayor Baskin's portrait because orbs often appear with him."

"I'm going to get the camera rolling and see if I can pick up any activity," Mitch said as they got off the elevator. "It may take a while before I spot anything."

"While he does that, Bill, will you guide us to the fourth floor?" asked Jules. "I have heard there are children on that floor. I want to set up some audio recordings and see what we can pick up on the EVP device. Maybe the kids will answer us."

"Let's take the stairs," Bill answered.

As they walked down the stairs to the fourth floor, Jules asked, "Have you heard the stories of children in the building?"

"Sure," Bill said. "I think my favorite story about the children happened in the restroom on that floor."

Beatrice was an executive assistant. She was proud of the work she did and didn't have time for shenanigans. She followed the rules and expected everyone else to as well.

One afternoon, she needed to be alone and escaped to the employee restroom. She checked to make sure she was alone and then entered a stall to sit down and think quietly. Her moment of solitude was broken by the giggling voices of children playing around. She'd had enough. She burst out of the stall.

"You children get out of here," she yelled. "You have no business being in here making a mess. How did you get in here anyway?"

The room was empty. The children weren't by the sink. One by one, she opened the stalls as she continued to berate the children.

"This restroom is reserved for employees. You need to go back with your parents and quiet down. This is a place of business," she said.

She found no one. Exasperated, she washed up and left—only to hear a ball bouncing down the stairs. That was too much. This was not a playground. She wanted those kids gone.

She called security, but they wouldn't investigate. Beatrice was always complaining about children and noises, and they never found anything. Finally, they blamed the commotion on the presence of two phantom children who had died during the construction of the building. That just upset her more.

"Did any kids die in the building?" Natasha asked.

"Yeah, the site had previously been a park," Bill answered. "During the construction of the building, a brother and sister were playing around on the construction site, fell down a shaft and died. The sculpture on the west side of the building is often thought to be a memorial to them. It was a gift from the children of Salt Lake City."

"This is great!" Jules said. "My new air ion counter is already showing some readings. Natasha, why don't you start the recorder and watch for any readings that might suggest communication? Maybe ask a question, like 'Are you here?' Let's see what we can pick up."

Bill went back to the fifth floor and found Mitch, who was excited to share what had happened. "You were right to tell me to film in the law library," Mitch said. "I got a great shot. As I was panning the tightly packed bookshelves with my video camera, I hesitated in front of a book that was not flush with the others. It seemed to be pushed forward, and then it slowly fell to the ground. I got it all on film. It was awesome. We should show the girls."

About an hour later, Bill and the ghost hunters gathered together on the third floor with all their equipment.

"Bill, why did you want us together on this floor?" Jules asked.

"I think the third floor has the most activity," responded Bill. "I am fairly certain one of the rooms is a portal."

"What do you mean, portal?" Natasha asked.

"A passageway between worlds," Bill said. "A doorway for easier access."

"Oh, that is so cool," Natasha said. "What room?"

"Don't say a word, Bill," Mitch interrupted. "If there is a portal, we should be able to find it with our equipment. Make sure you have the compass out and a thermometer."

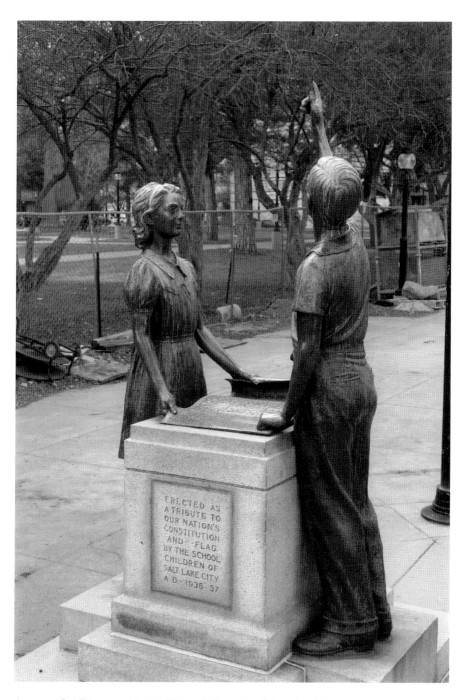

A statue of children outside the City and County Building. *Cassie Ashton.*

"You told us about the two children and the mayor," Jules said. "I have heard stories of a bride, a mother and a pioneer judge. Who else is here?"

"There are enough reports of female sounds and a nurturing feeling that I am sure there is a woman," Bill responded. "But the reports of a jilted bride or the mother of the children who were killed never made sense to me. The mother would be grief-stricken. But the descriptions are never sad, just busy and active. I have my own suspicions of who the woman is." Bill stopped and paused.

"Well, don't stop there—who, how, what?" said Natasha.

Bill smiled. He loved telling these stories.

"Nights are quiet," Bill continued. "The chaos and commotion of the day are gone. I was walking the halls one night, lost in thought. Suddenly, in the stillness, I felt a presence—or something—brush by me. I stopped. I looked around. Pausing, I took a deep breath, closed my eyes and listened.

"It was faint, but I could hear fabric dragging on the ground, like the swish of a full skirt—then the fading sound of clicking heels as someone hurried down the hall.

"I opened my eyes, but naturally, the hall was empty. I was on the third floor standing next to room 335, the room dedicated to Martha Hughes Cannon. Suddenly, it dawned on me; the ghost wasn't a mother or a bride. I am certain it is Dr. Cannon."

"Who is Dr. Cannon?" Natasha asked.

"Martha Hughes Cannon was the first woman to be a state senator in the United States," Bill said. "Mattie was a maverick, a force to be reckoned with."

Mattie immigrated to the United States as a child, arriving in Utah when she was four. By the age of fourteen, she was earning wages as a schoolteacher. Later, she worked as a telegraph operator so she could earn money to attend medical school. She traveled east to earn a medical degree, as well as degrees in pharmacology and elocution and oratory. When she returned to Utah, she became a resident physician at Deseret Hospital. It was there that she met Angus M. Cannon, who was the superintendent of the hospital. Mattie became Angus Cannon's fourth wife and had three children with him.

She was a strong advocate for women's rights and the suffrage movement. She did not mind being a plural wife because she felt it gave her more time and freedom to pursue a career. She believed women were better mothers if they worked. Mattie commented in an interview with the *San Francisco Examiner* shortly after she won her election: "Somehow I know that women who stay home all the time have the most unpleasant homes there are.

You give me a woman who thinks about something besides cook stoves and wash tubs and baby flannels, and I'll show you, nine times out of ten, a successful mother."

She also pursued a career in politics and became the first female state senator to hold office in the United States. She was a senator for the Sixth Senatorial District in Salt Lake County in 1896. The campaign attracted a lot of attention, not just because she was a woman but because she was also running against her husband in the election. She ran as a Democrat and her husband ran as a Republican, and she won. Her office was in the City and County Building. She served for two terms. She fought hard for better public health and to protect the rights of children and those with disabilities.

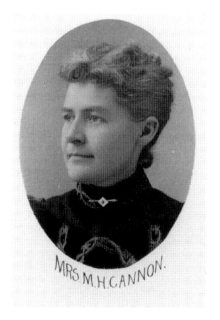

Martha Hughes Cannon, 1897. *Marriott Library.*

"Over one hundred years later, Mattie continues to receive attention by showing up in unexpected ways. It doesn't surprise me that she still roams the halls continuing to nurture our citizens. It makes more sense to me than a bride," Bill concluded.

"I like this gal. Have you seen her?" asked Jules.

"Yes, I believe I have. But mostly I hear her." Bill said.

They had walked into the city council chambers when Bill stopped.

"Hey, what does the thermometer say?" he asked.

"Wow, it is sixty degrees in here," Natasha said. "Do you usually keep the rooms this cold at night? And check this out, the compass is spinning. There are all kinds of electromagnetic fields bouncing off in this room."

"So what would you say is going on in here?" Mitch patiently asked.

"This is probably the portal Bill was talking about, isn't it?" Natasha answered, wide-eyed.

"Yep, this room has the original carpet and some original fixtures, which aid in maintaining the energy of all the people who have passed through here," Bill said. "It is near the room where I snapped a picture of a male ghost."

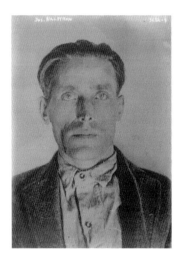

Joe Hill, 1915. *Library of Congress.*

"You have a picture of a ghost? How did you get that?" Jules asked.

"I was doing rounds one night about midnight when I walked into the corner office on the northwest side. There was a cold spot in front of the fireplace. I quickly grabbed my phone; you never know what you might get. I had captured the distinct image of a male ghost! The ghost was probably Mayor John Clark but maybe the judge or maybe Joe. If you want to see the photo, it was printed in the *Deseret News* on October 26, 2006."

"You really are good at this!" Jules said. "Maybe you should join our team of paranormal investigators. Sounds like you are a bit of a ghost magnet."

"I still want to know about the last ghost you mentioned," Natasha said, "the judge—or who else did you say?"

"The rumor is that a pioneer judge hanged himself or died of a heart attack from suspicious causes," Bill responded. "And he still walks the halls. You can recognize him by the steady syncopation of his walk due to his peg leg. I have heard it described as a tap, thud, tap, thud.

"I did a bit of investigating trying to find out who the judge was, but I couldn't find a record of a judge with an artificial leg. What I did find was Joe Hill."

Joe Hill was a jack-of-all-trades. He came to Utah in 1913 and found work in the mines in Park City. He had joined the IWW (the Industrial Workers of the World, or Wobblies) in 1910 and often wrote songs about the workingman's life. His songs were published in the IWW's songbook and were popular. They were often used in labor rallies or organizing drives and sung at rallies supporting strikes. Some say that the copper bosses didn't want him around to incite tension among the mineworkers.

In 1914, he was conveniently accused of murdering a store owner, though all evidence was circumstantial. Joe's guilt or innocence became polarized by labor issues and trial irregularities. The judge did call Joe into his chambers for a private chat, but Joe refused to give an alibi for his whereabouts the night of the murder.

The trial, held here in the Salt Lake City and County Building, ended in Joe's death sentence. It had gained national attention, and the sentence

was followed by national outrage. Telegrams flooded in. President Woodrow Wilson intervened twice, requesting a stay of execution. But when the stays ran out, Hill died in a fury of bullets on November 19, 1915.

"I think the mystery ghost everyone claims to experience is either the trial judge or even Joe Hill himself. He was known for saying, 'Don't mourn; organize!' In his last will, he quoted from a poem: 'Moss does not cling to a rolling stone.' Maybe he has organized a whole group of ghosts," Bill concluded.

"I suppose the wrongly accused may have a reason to cause a little ruckus every now and then," Mitch said.

"Have you ever sprinkled talcum powder in the hallways to see if you could catch any footprints?" Mitch asked.

"I haven't, but that is probably because I don't want to clean up the mess," Bill chuckled. "I think it would be fun to try. A great place to do that would be down in the tunnels."

"Do you mind if we come back another night and do that and continue investigating?" asked Mitch. "This has been marvelous. We have some great data to review, but I told your boss we would only stay a few hours."

"You bet," Bill replied. "I love swapping stories. Try to come back in the fall; the change of weather seems to elicit new activity."

"One thing is for sure," Jules said, "the ghosts in this building have some distinct personalities. This place is great. Thanks for all your help tonight. It has been eye-opening."

Jules gave Bill a quick hug, and they headed down the steps of the majestic old Salt Lake City and County Building.

Bill waved and watched the ghost hunters drive away. He turned around and gazed at the building that he had promised to watch over and protect.

He chuckled to himself as he realized that even though one hundred years had passed, the old building was still doing a good job keeping up with its architectural rival, the Salt Lake Temple.

Those who visit the Salt Lake Temple honor those who have passed away. And those who have passed away visit the Salt Lake City and County Building. Smiling to himself, Bill thought, I am grateful to be a guardian of the ghosts. He went back inside to finish his shift.

CHAPTER 4

DENVER RIO GRANDE DEPOT

300 South Rio Grande Street

BY KRISTEN CLAY

S he dreaded stepping back out of the ladies' restroom into the corridor. Earlier, on her way into the ladies' room, she was taken aback by the strange crowd of people milling about.

Something was unsettling about the way they looked disconnected and lost. But that wasn't all: their manner of dress was as varied as their ages. Men, women and children, attired in fashions ranging from what appeared to be the latter part of the 1800s to the mid-1900s. Briefly wondering if they might be actors preparing for a performance, she slipped by them as fast as she could into the welcome vacancy of the ladies' room.

Her heart pounded and her freshly washed hands began to sweat as she reached for the door. One step into the passageway and the hair on her neck and arms stood on end. She had to turn and walk sideways to be able to squeeze through the now even more crowded hall. Finally, reaching her table in the Rio Grande Café, she felt her hand tremble as she reached for her cool drink. Her lunch companion noted her pale complexion.

"What a peculiar crowd; look how they're dressed. Why do you think they are all gathered in the corridor like that?" Eyeing them once again, she whispered, "They kind of give me the creeps."

"What crowd?" her friend replied, nonchalantly glancing in the direction of the restrooms and continuing her meal.

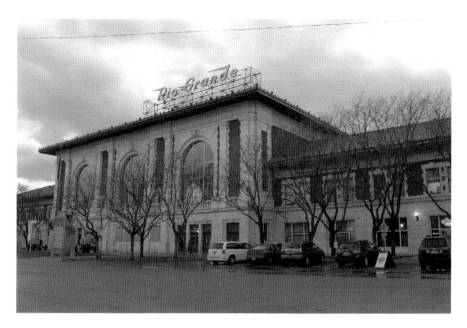

The Rio Grande Depot, home to the Utah Historical Society, Utah Arts Council, Utah State Archives and Records Service, the Rio Grande Café—and ghosts. *Nannette Watts.*

Waving the server to her table, she inquired about the eerie throng assembled just outside the dining area.

"I don't see anyone out there. It's been a slow day," the amiable server smiled and set the check on the table.

Without even glancing at the check, and with a vow to never return, the diner quickly dropped a couple of twenties onto the table and briskly ran out of the building, leaving her companion and server mystified.

Perhaps the mysterious otherworldly guests from the past understood that a railroad will get them somewhere, anywhere, even if they are unsure where that is. Everyone knows that to catch a train, you go to the depot.

RAILROAD RIVALRY

The origin story of the Denver Rio Grande Depot is entrenched in the cutthroat rivalry between two powerful railroads—the Union Pacific (UP)

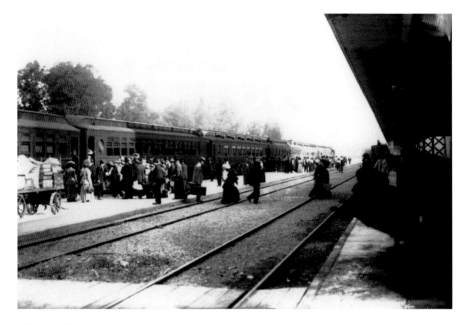

All aboard! One of the first passenger trains to leave the newly constructed Denver Rio Grande Depot, 1910. *Marriott Library.*

and the Denver and Rio Grande (D&RG)*—and their head tycoons, Edward Harriman and George Gould, respectively.

Having a monopoly on all the railroads is a wonderful thing in the game that many know and love. However, the Union Pacific's virtual monopoly on Utah's railroads did not please a lot of folks, including railroad mogul George Gould. The meeting of the rails in 1869 connected the Central Pacific and Union Pacific railroads at Promontory Summit, Utah Territory, completing the first transcontinental railroad across the United States. The UP thereafter maintained control of the territory's railroads for quite some time.

At the end of the 1800s, the railroad had become the country's largest industry. The inception of the D&RG was almost completely bypassed. Utah was not even in the initial running for the D&RG to pass through. Eventually, the D&RG built a network of branch lines challenging the UP's control and monopolizing the transport of coal outside the state.

The race of the rails was on between Gould and Harriman as to whose transcontinental railroad would dominate. The feud escalated to the point that Harriman threatened Gould, "If you build that railroad, I'll kill you!"

* The Denver and Rio Grande Railroad, including all its branches and subsidiaries, will be referred to simply as the Denver and Rio Grande Railroad or D&RG.

Gould did it anyway. By 1909, under the direction of George Gould, the Western Pacific Railway completed construction of its line into Salt Lake City from Oakland, California.

The UP had a shaky relationship with the leaders of the Church of Jesus Christ of Latter-day Saints, who had a great deal of political pull. The UP had broken a contract with the church, resulting in the loss of much-needed labor for the members, as well as a significant loss of money. When a settlement was reached, the church was paid only a fragment of what it was owed, and this was mostly in stocks. As a result, the competitor, the D&RG, was welcomed. Lack of competition had resulted in high ticket and freight prices. Utah's natural resources had also been underdeveloped due to lack of transportation. Gould seized the ripe opportunity this economic and political climate offered and selected Salt Lake City to be the western hub of the D&RG, connecting the new transcontinental routes.

The two railroads increased their rivalries with what the newspapers described as a "freight war." The UP drastically cut its ticket prices between Salt Lake City and Ogden, while the D&RG responded with free commutes between the two cities.

MONUMENT TO BYGONE DAYS

The enmity between the dueling railroads benefited the masses, and in an effort to outshine its competitor, the UP constructed a remarkable depot complete with double towers, domed ceilings and stained-glass windows. The stately station was guarded by elaborately carved gargoyles. Not to be outdone, George Gould began construction on an imposing depot of his own only a few blocks away. It was a project that would be fraught with setbacks and turmoil and would eventually contribute to the tycoon's bankruptcy.

Henry S. Schlachs, a distinguished German-born architect out of Chicago, was commissioned for the grand project of designing and overseeing the construction of the Denver Rio Grande Depot. He had designed churches throughout the West and Midwest and a main line depot in Denver. The railroad depot was the first impression of a city for travelers, and its importance could not be overstated. The Denver Rio Grande station in all its grandeur, regardless of great impediments, was completed in 1910 with the final price tag of $750,000.

The impressive depot offered modern comfort and convenience to weary travelers. It stood as a monumental showplace to visiting dignitaries and was the stage for farewells and homecomings of soldiers and families in World War I and World War II. It serviced so many trains that tracks, side by side, stretched out for a couple of blocks. The depot offered an immediate economic boom to the neighborhood, extending as far as Main Street. Real estate values increased, and elegant hotels and restaurants were constructed nearby. Flourishing ethnic communities built up immediately surrounding the depot, as newly arriving immigrants chose to settle in the welcoming depot's shadow.

Just as Gould imagined, the depot became the transcontinental heart of the West. Massive numbers of commuters from across the country passed through its thresholds, and passenger and freight trains filled its expansive yard. The boon was not long lasting. Gould's business dealings at the beginning of the century led the railroad into financial failure by the 1920s. Railroads throughout the nation felt the devastating impact of the Great Depression. In the 1930s, the Rio Grande, like many other depots across the country, fell into disrepair.

Fortunately, Salt Lake City's Denver Rio Grande experienced a revitalization. The reason, however, was not so pleasant. World War II brought with it the need to transport large numbers of soldiers. As many as fifteen to twenty trains filled with servicemen and women passed through the depot daily. In addition, rationing of gasoline forced civilians onto the rails to meet their transportation needs. The station became so crowded at times that the trains had to wait blocks away, with passengers waiting for hours to disembark.

Most forbidding of all were the "Mortuary Specials": trains filled with the dead returning from battle. Historian Brandon Johnson, formerly of the Utah Humanities Council, interviewed a former station master who said, "These mortuary trains were all like twenty-five, thirty cars, and they were all painted gray, all sealed up, and it just gave everybody a funny feeling."

The war ended, and so did the resurgence. Interstates now connected the nation, automobiles became more affordable and suburban sprawl moved people out of the cities and away from transportation hubs. The profitability of passengers diminished, and railroads made the transition to freight only, making passenger depots obsolete. After the Denver Rio Grande Depot fell into disrepair once again, the railroad had to decide between tearing it down or selling it. Fortune smiled upon the depot, and in 1977, the State of

Utah purchased it for one dollar. In the spirit of preservation, the depot was restored to its former glory.

Today, the magnificent building houses the Utah Historical Society, the Utah Arts Council, the Utah State Archives and Records Service, the Rio Grande Café—and ghosts.

The Purple Lady and Otherworldly Travelers

The most well known of the ghosts inhabiting the building is known as the Purple Lady, also referred to as the Raven-Haired Beauty. The Purple Lady legend that has been passed down by word of mouth through the last several decades is that of an enamored young woman who, with eagerness, waited for her soldier's return from the war.

Gloria Simmons was in love. She counted down the days until Orton would return home. The newsreels were calling those young men who invaded the beaches of Normandy heroes. She couldn't have been prouder of her soldier and his part in what had begun to be called D-Day.

Finally, the day of his homecoming arrived. He was scheduled to arrive by train along with many other soldiers at the Denver Rio Grande Depot.

In her excitement, Gloria dressed up in her finest attire. Wanting to impress him, she put on her favorite purple dress, the one her friends said brought out the highlights in her eyes. She adorned herself with a purple pillbox hat that sported a lovely slight veil of purple tulle. Her raven-colored hair was styled to perfection.

She arrived at the depot early; she wanted to be the first person her love would see upon his arrival. She waited on the platform, holding her breath as each train pulled into the station.

"My hero," she repeated to herself over and over, the anticipation building with each approaching train.

The moment she had been waiting for arrived. In rolled a passenger car full of uniformed young men. Her soldier, catching her eye, leapt from the train before it even came to a complete stop.

The young lovers rushed into each other's arms and enveloped each other in a fond embrace. Before she could utter a word, and in a grand gesture, Orton dipped her back and kissed her on the lips. Giggles, cheers and whistles erupted from the bystanders witnessing the romantic reunion.

Blushing, Gloria began to chatter, catching him up on all that had happened while he had been away. She told all the little details that couldn't possibly fit into a letter.

"My sister back home in Alabama just found out she is going to have a baby. My best friend Peggy just got engaged. We have been having so much fun hosting the dances for the soldiers," she gushed.

"What dances?" Orton inquired.

"You know, the dances for all the soldiers coming in on the trains and laying over. I'm sure I told you about them in one of my letters," she naïvely answered. "Remember, I even told you about the poor soldier that I have been writing to because he has not received any letters since he has been away."

"No, I do not," Orton angrily refuted.

The lovebirds began to quarrel. One thing led to another, and in anger, the young woman took off her engagement ring. "If you don't trust me, maybe we shouldn't be getting married after all!" she cried out, shoving the ring into his hand.

"Maybe you're right!" he countered, fuming at the turn their reunion had taken. Not to be outmaneuvered by her angry demonstration, he impulsively threw the ring. It landed directly on the tracks.

He must have underestimated the meaning of that token of affection to her because, without even looking, she dove onto the tracks to retrieve the ring and was struck by an oncoming train.

She has remained in the station since that fateful day. Most notably, her apparition has been experienced in the ladies' restroom near the Rio Grande Café.

A clairvoyant shared her impressions of the Purple Lady, including specifics as to the young couple's names, backgrounds and the reason for arguing. She ascertained the reason behind this haunting is that the Purple Lady is upset and wants her story told.

Patrons of the restaurant and visitors to the various state agencies housed in the depot often share a common experience. One woman, while washing her hands in one of the six sinks forming an island in the center of the ladies' room, noticed the reflection of a striking woman in the mirror across from her. She smiled politely, musing about the woman's strange demeanor and dress. The woman was adorned in a purple period dress. The pillbox hat she wore gave her a strange purple glow, as the tulle veil slightly protruded past her forehead. A chill ran down the woman's spine as she turned to get a better look and properly greet the other woman. The stranger was staring

at her with such sadness in her countenance. But when she looked where she perceived the woman to be standing, there was no one there.

A patron on Story Tours and a former server at the Rio Grande Café had an equally perplexing experience in the ladies' room. While washing her hands, she had a sense that she was not alone. From the corner of her eye, she briefly caught a glance of a lady adorned in purple across the room reflected in the mirror. Each of the antique sinks, with separate hot and cold antique faucets, began to turn on by itself. Round robin, one at a time, each sink in the island began to spew water, hot then cold, and then on to the next sink. The toilets joined in the cacophony, one at a time, flushing until each had its turn. When she recovered from her mesmerized stupor, she rushed out the room, never to return without a coworker.

Many other ghostly encounters have been reported throughout the remarkable building. Two security guards were making their rounds early one morning while the building was still locked. As they passed the kitchen on the north end of the building, they heard a baby crying. Expecting to find a lady and an infant, they searched the building. No one was to be found. This disembodied child has been nicknamed the Purple Baby.

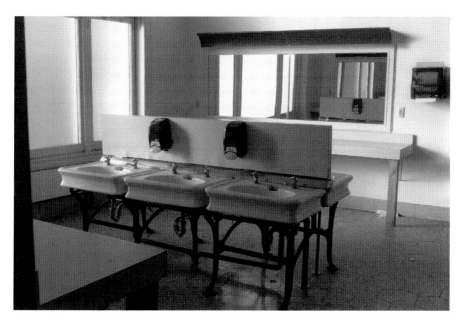

The haunted ladies' room where the Purple Lady appears in the mirrors. The old-fashioned faucets are known to turn on one at a time. *Nannette Watts.*

One of the librarians describes regularly hearing murmuring voices when she closes the library for the evening.

On another occasion, a custodian was mopping the floor when the lights went out. He made his way over to the breaker box. He felt a presence and then heard a voice say, "Get out now!" He did not waste any time exiting the depot.

One psychic offered a noteworthy theory as to why the building is so paranormally active. "Since the train was the main mode of long-distance travel spanning from the late 1800s to the mid-1900s," she suggested, "when a person wanted to go somewhere, they went to the depot to start their journey.

"Perhaps the many specters gathering in the depot do not know they are dead," she explained, "and in their confusion, they are simply trying to go to the one place that in their lives they knew would lead them somewhere...anywhere."

The legend of the young lovers has been passed down for decades and has become part of the common lore. The collective experiences and descriptions shared by those sensitive individuals who have dared enter the ladies' room alone have cemented the narrative. However, in recent years, with the advance of technology, a twist may be added to the story. In 2002, a group of ghost hunters set up recording equipment, and when they played it back, they heard a voice whispering, "He pushed me!"

CHAPTER 5
DEVEREAUX MANSION

340 West South Temple Street

BY LAURIE ALLEN

The security guard walked quickly toward the house and paused at the front door. Every light was on, and there was a distinct sound of dishes and silverware being used and glasses clinking, along with talking and laughing, though no words were decipherable from outside. The sounds were definitive: a party was being held in the home. He tried the master key; some of the security workers complained that their keys would not work at this location.

"They always let me in. They seem to like me," he thought.

He put his hand on the doorknob and began to enter the house. As soon as he did, the entire place became instantly dark and silent. That was as it should be: no parties were scheduled for the Devereaux Mansion that night—these guests were not among the living.

THE PARTY THAT NEVER STOPS

The Devereaux House was originally built for William Staines by architect William Paul in 1857. It was the first mansion constructed in the Utah Territory and thus was the location for many parties and activities of "state" in the fledgling territory (settled just ten years previously). The home's historical significance was assured because of the part it played in the Utah War.

The Devereaux House, restored to its former grandeur, is now used for receptions, social and cultural events, 2017. *Laurie Allen.*

In 1857, U.S. president James Buchanan sent an army under the direction of Colonel (soon to be General) Albert Sidney Johnston to the Salt Lake Valley to escort a new territorial governor, Alfred Cumming, to take command from Brigham Young. Young was the leader of the Church of Jesus Christ of Latter-day Saints (Mormons) and Utah's first governor. Although the Church had sent over five hundred men (the Mormon Battalion) to fight for the United States in the war with Mexico, false reports had been carried back east that the Mormons were in rebellion against the government. Buchanan felt that it was time to put a new governor in place in the territory. Young promised Buchanan that Cumming would receive an escort by the local militia and be treated well, but Buchanan was still nervous about the situation, so the army continued to proceed under presidential orders.

Young was understandably worried about a military presence coming into the city after the persecutions and mob violence that the Mormons had suffered in Illinois and Missouri due to their religious convictions. They had traveled many miles to escape such problems. All he wanted was peace for his people and the ability to practice their religion and safety for their families.

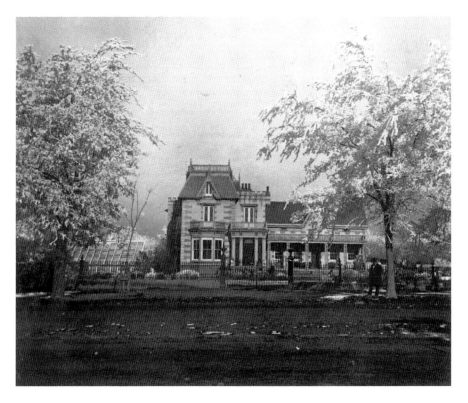

The home, built for William Staines, was the first mansion constructed in the Territory of Utah, seen here circa 1858. *Marriott Library.*

Young sent the Utah militia into Echo Canyon to harass the army of 2,500, which kept them from entering Salt Lake City until 1858. During this time, a letter was sent by messenger to Colonel Thomas L. Kane, a man of influence who was sympathetic to the Mormon cause, to have him come as a mediator and help settle things peaceably. Because Brigham Young feared the army's coming, he put the city under martial law and told the residents to pack their belongings and head farther south until things could be resolved. Typical of Young's leadership style, this migration was done in an orderly manner and took nearly two months. The Mormons were determined to burn their homes to the ground, if necessary, before they would once again let anyone take over what they had worked so hard to build.

The only home left occupied in Salt Lake City was the Devereaux House, and here Staines offered a place for the negotiations. Governor Cumming, Colonel Kane, Brigham Young and other leaders met in the house and

worked out the details for a peaceful settlement. Governor Cumming would be the new territorial governor, with all the respect due to that office. The army would walk through the city, without arms, and settle down west of Salt Lake City at Camp Floyd. No shots were fired in this "war," and the people returned to their homes and their peaceful lives, grateful that the potential tragedy had been averted.

Ten years later, in 1867, the house was bought by William Jennings and named the Devereaux House after an estate near Birmingham, England, where he was born. He built another wing to the house, expanded the landscaping with formal gardens and added several outbuildings, making it a true showcase. Much of the beauty in the house was due to local craftsmanship, as the railroad had not yet reached the area and materials had to be transported long distances by wagon. The outer walls were made of brick and covered with stucco scored to look like stone. Many interior areas were painted to resemble marble, pine was sometimes used and "false grained" to look like hardwood, porches and balconies surrounded the house and there was a notable amount of French influence in the design.

During this era, President Ulysses S. Grant, General William T. Sherman and Secretary of State William H. Seward were all hosted in this house, which sometimes boasted parties of up to three hundred. In the early days of the territory, wealth was often associated with the railroad, and Jennings's money was no exception. He was involved with the Utah Central and

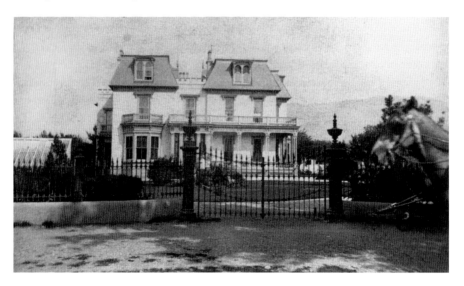

William Jennings purchased the home, made additions and named it the Devereaux House, seen here circa 1871–75. *Marriott Library.*

Utah Southern Railroads. When his daughter Jane was married, he had a temporary rail line installed in the Devereaux backyard so the couple could leave for their honeymoon directly from the lavish reception.

The home itself was located close to the railway station, so the area was becoming commercial as the railroad became more important to the economy of the city. With industrial encroachment and Jennings's death in 1886, the house began to decline. The large estate was sold and divided up, and some parts were used for commercial pursuits, including a scrap metal company, a clandestine bootlegger business during Prohibition and, in a seeming contradiction, a rehabilitation center for alcoholics. The home was eventually divided up into apartments during the early part of the twentieth century. With the home's decline, other influences began to be felt within its walls. Mrs. Shober, who was a young teen living in the house sometime between 1918 and 1929, said, "I always thought it was haunted, especially in the living room. I felt like someone's presence was in there."

The house was listed in the National Register of Historic Places on March 11, 1971, but it was in a tremendous state of disrepair. The State

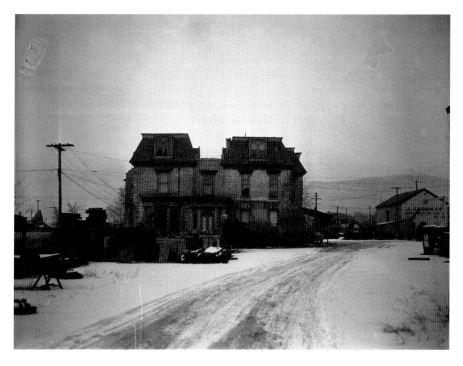

This photo shows the home in a complete state of disrepair due to fire and neglect, circa 1957. *Marriott Library.*

The stairway in the mansion where guests have observed a child "watching" the parties. Is he still there? *Library of Congress.*

of Utah had bought the property, and it was scheduled for demolition in 1978. A fire in 1979 destroyed parts of the home, and abandonment had nearly completed the process of dereliction. Historical societies and public sentiment intervened for the once-beautiful edifice, and today, a gracious mansion stands as a symbol of restoration. The Chart House Restaurant

owned the building for a time, and now the Church of Jesus Christ of Latter-day Saints has ownership and rents the home for receptions and cultural events. This seems to be when the ghostly occurrences began in earnest.

There is a glass-front cabinet that is original to the house in one of the front rooms. While the Chart House Restaurant was there, items would sometimes disappear: restaurant items, guests' personal items, sometimes even checks. Whenever these items went missing, they were always found inside the cabinet.

In the early days, children were not allowed to frequent the parties and social occasions inside the mansion, and some homes had windows or viewing areas available above the stairs so that the small ones could see the fancy guests arriving before their bedtimes. Devereaux was not so outfitted, but a fair amount of viewing could be done from the top of the stairs, at least until the young recreant was spotted and shuttled off to bed. Guests in the Chart House would sometimes report a child sitting on the top of the stairway…a child who disappeared suddenly when the person tried to get a better look.

The home is located just west of the Triad Center, a large office building complex, so at times the security from the Triad Center would be responsible for the Devereaux Mansion also. The guards report lights going on repeatedly during the night, even though attempts were constantly made to keep them turned off. Finally, they just let the ghosts have their parties—after all, they would turn the lights off when they were done! Security keys would not always let the guards in the home anyway, unless the ghosts particularly liked the guard, and then the keys would work. From the vantage of the Triad Center (quite a bit taller than the mansion), people could be seen walking past the windows. This would also be picked up on security cameras, even when no one had the building rented for the evening. While walking down the hallway one night, a guard reported that the hanging pots and pans started rattling in the kitchen, though nothing was out of place when he reached that room. Parties tend to stop when someone living checks, but who desires an unwanted visitor at their party anyway? This home was such a major social center for a time that it's not surprising that the activities haven't stopped. After all, who doesn't enjoy being entertained in the grand style?

CHAPTER 6
FORT DOUGLAS

32 Potter Street

BY KRISTEN CLAY

Will you come out and take a picture of us with that guy in the Civil War uniform?"

Before the advent of selfies, families were known to enter the Fort Douglas Military Museum and ask the staff to take a picture of them posing with "the guy in the Civil War costume" who leans against the post on the long museum porch smoking a pipe. Patrons often become quite incredulous when the staff explains that there is no costumed character on site. When guests step back onto the porch or look over their shoulders or out the window, they are often chilled to the bone to realize there is no trace of

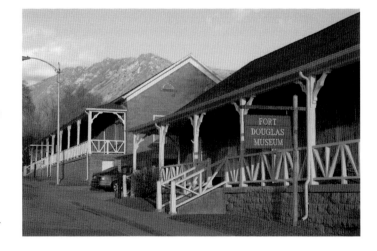

At Fort Douglas Military Museum, Clem is often seen leaning on the porch smoking his pipe, as well as flirting with the ladies, 2018. *Nannette Watts.*

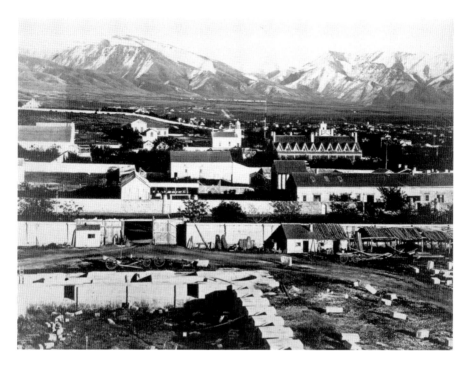

View of Camp Douglas and Wasatch Mountains from downtown Salt Lake City by Andrew J. Russell, 1868. *Marriott Library.*

the pipe-smoking soldier. The knowledgeable staff then offer the bewildered family a tour and share the history of the site.

THE MORMONS AND THE MILITARY

The first Mormon settlers entered the Salt Lake Valley in July 1847. Wagon trains and handcart companies traveling one thousand miles, often on foot, continued to join their fellow Saints in large numbers to where they hoped to settle and live their religion in peace. Due to the mass migration of seventy thousand members arriving in the valley between 1847 and 1869, there were some in the federal government who were wary of the growing numbers of Mormons in the West. Although their fears were unfounded, they were apprehensive of the power they believed the Mormon prophet, Brigham Young, had and feared secession. It was decided a military post was necessary.

Originally, it was called Camp Douglas, named after Senator Stephen A. Douglas of Illinois. Colonel Patrick Edward Connor's volunteer army was commissioned to guard the Overland Mail Route as well as keep an eye on the Mormons. They claimed a place on the east bench of Salt Lake City to set up camp.

At one point, while tensions were particularly high, Connor, a staunch anti-Mormon, threatened to point a cannon at the Beehive House, the official residence of Brigham Young. With time, the suspicions of secession died down, and some semblance of tolerance was established between the two parties. The Eighteenth Infantry army was eventually replaced by the volunteer armies.

Regardless of the initial mistrust between the Mormons and the army, the Mormons remained loyal to the United States.

In 1878, the camp's name was changed to Fort Douglas, warranting its importance as a military establishment. The garrison ensured supremacy over the indigenous peoples and supplied the cavalries moving about the West.

Utah's U.S. senator Thomas Kearns was instrumental in Fort Douglas becoming the regimental headquarters in 1901. This post grew in size and became a training facility for soldiers. During the world wars, Fort Douglas also served as an internment and a POW camp.

Over the years, portions of Fort Douglas were granted or sold off to the state, the University of Utah and other entities. Only a small portion on the southwest side is utilized by the U.S. military today. It is now the headquarters of the Ninety-Sixth Army Reserve Command and is a base of operation for U.S. Navy and Marine reserves.

In 1970, the historic area of Fort Douglas, including what is now the museum complex, was designated as a National Historic Landmark.

CLEM: LADIES' MAN OR MENACE?

The museum complex, located on the northwest side of Fort Douglas, is the favorite haunt of Clem. He is a well-loved yet mischievous ghost who seems to fancy himself a ladies' man.

After hearing the consistent detailed descriptions of Clem's uniform, hairstyle and beard, a museum staffer was able to determine that Clem wears a post–Civil War uniform. Museum specialists believe that Clem was stationed at Fort Douglas after 1865 and that he worked in the livery

An unidentified soldier in sergeant's uniform with musket, taken between 1861 and 1865. This unknown soldier closely resembles the many descriptions of Clem. *Library of Congress.*

stables because that is the area where he is most frequently spotted. Although Clem tends to favor certain locations, he has been identified all over the compound.

Security guards on the University of Utah campus, once part of Fort Douglas, have on occasion received complaints from young female students about a "guy in a Civil War uniform" following them around, pulling their

hair or even slapping them on the behind. They will demand that something be done immediately. Dutiful security guards, who are familiar with Clem's antics, perform a thorough investigation and, with time, after hearing the consistent description of the vanishing perpetrator, realize they may literally be chasing a ghost.

CLEM: THE GHOUL AND THE GIRL SCOUTS

Due to the perpetual paranormal activity at the site, the museum is a favorite stop for Story Tours: The Salt Lake City Ghost Tours. One late spring evening, a full busload of Girl Scouts stopped by the museum. The girls and their leaders listened intently to the guide as she regaled them with stories of Clem and other ghostly visitors. With a mix of trepidation and giddiness, the tweeners, teens and chaperones disembarked the bus to explore. The guide stationed herself at the top of the museum complex, keeping an eye on the capricious group, hoping they would not disrupt the students prepping for finals in the nearby university housing or, with a mix of giggles and shrieks, attract the scrutiny of security. The guide's apprehension and constant scanning were unwarranted. The group conducted themselves with good manners, and the tour went on without a hitch—or did it?

Early the next morning, the guide received a call at home, waking her from sleep. It was one of the Girl Scout leaders. With a tremor in her voice, she asked, "Did you hire that Civil War guy? You did, didn't you? I'm sure you did!"

"What?" the guide responded sleepily.

"I know you guys are pulling a trick on me! The Civil War guy; he was a plant, right?" She pleaded, "You hired him!"

Now more awake and starting to realize something had happened the night before, the guide sat up in her bed and calmly asked the leader to tell her exactly what had happened.

The leader explained that as they stood on the edge of the porch watching the girls, a man in a Civil War uniform appeared below in the drive between the two buildings. He stood there, tipped his hat and waved and blew kisses at her. She giggled and pointed him out to the other two leaders standing with her.

They said, "What guy?"

"That guy right there, the one waving at us and winking!" she insisted.

Fort Douglas
porch. Clem
has been
spotted below
waving to the
ladies and
lurking in
the shadows.
Nannette Watts.

"I don't see anyone down there," they both maintained.

The guide had called everyone back to the bus, and the tour resumed with the leaders dispersed among the scouts. At the end of the tour, the ladies regrouped with their carpool. Once again, the leader mentioned the flirtatious Civil War soldier, and once again, her friends denied seeing him. The hair rose on the back of her neck. She was chilled through and through, and her arms were covered in goose bumps. In desperation, she begged them to stop teasing her. They continued their denial. As they parted ways, she was discouraged and annoyed by her friends' "joke."

"Why can't they just admit it? Why can't they let me in on the joke?" she thought. Even her very own daughter, a Girl Scout, seemed to be in on the gag.

She tossed and turned all night, pondering that the most disturbing part of the prank was how vehemently the others denied seeing the man. Could her dear friends, whom she had known for so long, be such good liars?

"Why would they continue with the hoax," she cried, "even when they saw how disturbed I was? And to top it all off, they accused me of being the one spinning the yarn!"

So, at six thirty in the morning, she woke the guide, hoping to put an end to the caper.

The guide now had shivers up her spine as she replied, "I don't know how to tell you this—but you just met Clem."

While Clem is one of the most well-known and beloved ghosts of Fort Douglas, with his innumerable shenanigans and countless interactions with

the living, he is certainly not the only ghost inhabiting the large compound. Ghostly encounters have been reported in the Fort Douglas Cemetery. One father, while visiting his son's grave, took a picture of his living son next to his brother's headstone. When the father got the film developed, there was another man standing next to his son overlooking the grave.

OTHER POLTERGEISTS AT THE POST

Forming a semicircle around the parade grounds, the old officers' houses stand as eloquently now as they did in the beginning. Officers lived in the stately duplex houses with their families. Over the years, as families began to talk among themselves, they realized they were not alone in experiencing strange phenomena in their homes. At first, they would accuse their children and spouses of misplacing and losing objects that would later be found in peculiar places.

Fort Douglas officers' houses, home to past officers, current students and prankster poltergeists. *Marriott Library.*

One family had a house guest who, while getting a glass of water in the middle of the night, witnessed a woman materialize out of thin air in the kitchen next to him. The woman coquettishly smiled at him, opened the cupboard, took out a bowl and a few other dishes and then glided down the stairs. Incredulously, the young man followed her into the basement. He watched her reach up, with her feet on tippy toes, and place the dishes on a support crossbeam that ran the length of the house. He ran all the way up the stairs, knocked on his hosts' bedroom door and frantically beckoned for them to follow. Out of breath and speechless, he returned to the basement, pointing to the beam. Climbing on a chair, the woman of the house inspected the crossbeam and then, shaking her head in dismay, stated with a chuckle, "So that's where all my dishes have been disappearing." The young man did not share her humor; next time he was in town, he found other accommodations.

Institutions of Intrigue

It was the picture caught on the camera from the Old Fort Douglas Hospital that caught the attention of research administration at the University of Utah. Ghost hunters set up cameras during the remodeling and discovered the history of the institutional building is intriguing. At one point in time, the main floor was a hospital, the basement held a temporary morgue and the second floor was the insane asylum. The insane asylum explains the picture. A man in a straightjacket can clearly be seen in the photo.

Security guards reported they had seen apparitions and heard voices in this building while it was vacant. One guard even claims she felt someone or something put its arm around her. For a while, the building served as housing for international students. Several individual families reported ghostly activity while they stayed there. They would experience furniture being rearranged when they turned their backs or momentarily stepped out of the room. Someone even had to call the fire department when the sprinklers went off without explanation.

Heather, a longtime employee, said that there hasn't been as much activity reported since the huge remodel. But that depends on to whom you are talking.

A lady on the second floor swears her chair spins in circles on its own. Two men who worked during the reconstruction had so many

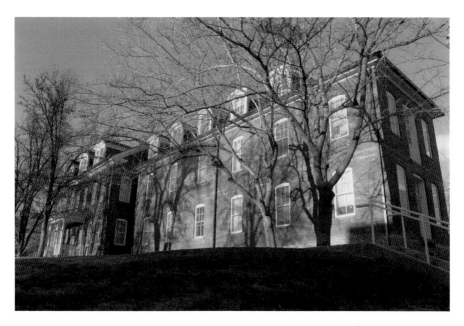

Fort Douglas Hospital, now the Administrative Research offices for the University of Utah, 2018. *Nannette Watts.*

unexplainable experiences that they refused to return to the building, even during the day. Another staff member, CK, said his dad was alone in the building making repairs when he walked into the attic and passed a mannequin. When he walked out of the attic, he realized that the mannequin had vanished into thin air. The spooky attic was remodeled and became third-floor offices. The research administration staff didn't like the basement's old morgue reputation, so they now refer to it as the Garden-Level offices. The new name takes their minds off what used to take place where their offices now are.

There used to be a screened porch along the west side of the building where people were sent to "breathe" during epidemics. The original ambulance house on the northeast side of the building still stands and has been changed into offices. Workers report ghostly activity, such as furniture moving by itself, and often feel a presence within the building.

Perhaps the caretakers of old Fort Douglas have continued to remain diligent in their posts.

CHAPTER 7

INN ON THE HILL:
WOODRUFF MANSION

225 North State Street

BY NANNETTE WATTS

I n 1906, Dr. Edward Day Woodruff and Minnette Myrtle Roberts Woodruff built the elegant mansion that would become the historic Inn on the Hill.

Edward Woodruff had been a surgeon for Union Pacific Railway in Rock Springs, Wyoming, where his practice was lucrative. The Woodruffs joined Christian Scientists before moving to Utah, where Dr. Woodruff gave up medicine for religious convictions. He became involved in the community and as president of the Brown, Terry, and Woodruff Company, founding the Troy Laundry.

The Woodruffs looked forward to living in the beautiful Second Renaissance Revival manor with their four children. They hired architects Headlund and Wood to create the style of an English manor.

The family's eleven-thousand-square-foot home was built in 1906. Interior work was superior, including Oriental rugs and Tiffany stained glass. The walls were covered with leather and canvas and then painted by local artist William Culmer.

Their world was enviable, but things happen in life that test happiness, peace and love.

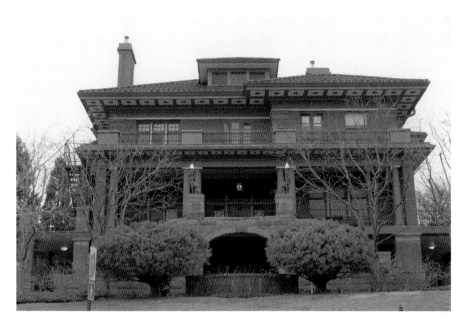

The Inn on the Hill, or Woodruff Mansion, entrance. *Nannette Watts.*

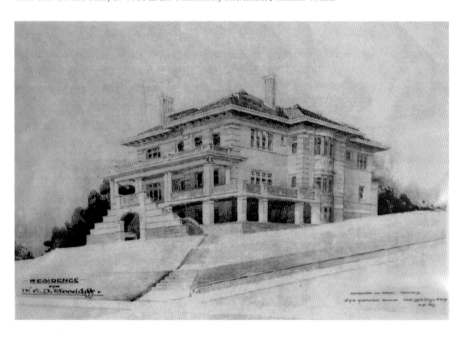

Woodruff Mansion rendering. *Courtesy of the Inn on the Hill, Lawrence H. Hill collection.*

LOVE ENDURES

Edward Woodruff, between 1901 and 1915. *Courtesy of the Inn on the Hill, Lawrence H. Hill collection.*

In 1925, Minnette was diagnosed with cancer. Edward cared for her in their home, staying constantly by her side. Edward saw that Minnette had trouble sleeping. Not wanting her to be disturbed by his regular schedule, he moved from their bedroom to another across the landing, hoping she would sleep better.

The last few weeks of her life, Edward went into her room every fifteen minutes and asked her, "Are you all right? Do you need anything?"

She died with him by her side. He died only two months later, perhaps of a broken heart.

The Woodruffs' married daughter inherited the home following Edward's death. The couple had no children, so upon passing, the house was sold in 1950 to DeVirl Stewart. Various owners turned the home into apartments and an office building until 1996.

Potential was seen in the old mansion in 1998, when it was restored by owners Marla and Dan Oredson. The Inn on Capitol Hill held thirteen suites, each reflecting a period of Utah's history. The McCarthey family purchased the inn in 2004, and it is now Inn on the Hill. The original grandeur inside and out has been restored. Perhaps the restoration acted as an invitation back to the mansion because ghostly activity has increased.

ARE YOU ALL RIGHT?

Summer walked down the stairs of the inn to the front desk and flopped into her chair. The front desk was actually at the back of the mansion turned bed-and-breakfast. She wore a smile that she tried to make sincere in case any patrons came by.

As a student, she had landed her dream job. She worked in a low-stress atmosphere with time to study—if none of the guests needed anything. In the quiet moments, she could do all required reading to keep her grades up.

Her duties at the inn were simple: keep guests happy. That meant cleaning, displaying a cheery countenance, answering phone calls and running to the storage room to gather supplies.

The storage room—this was the thing that troubled Summer about the job. She detested the storage room. It was located in the attic of the old mansion, and she couldn't quite put her finger on why she disliked it so.

Summer loved the rest of the mansion; it was intriguing and inviting. An overwhelming love seemed to emanate throughout the main floors of the home—as if someone were whispering to her: "Good work" or "You can do that." The feeling made her want to work harder.

For some reason she could not explain, she associated the feelings with the home's original owners. A portrait of Edward and Minnette Woodruff hung near the reception desk. Edward was tall and thin while Minnette was shorter and had a beautiful smile. Summer could feel the love that seemed to emanate from their portrait and permeate the mansion.

Her interest in the original owners of the mansion led her to learn all she could about their tender story. She heard the story of the tragedy in their lives from the hostess who trained her.

"When Minnette was diagnosed with cancer, her faithful husband, Edward, took care of her as she lay dying," the trainer told Summer. "Every fifteen minutes, he would stand over her bed and inquire, 'Are you all right? Do you need anything?'"

"Now don't share this with the guests," her trainer told her, "but the funny thing is that time after time people who stay in that room will come down to breakfast and say, 'A nice man stood over our bed last night and asked, "Are you all right? Do you need anything?"'"

"That's crazy," Summer said in surprise. "Why don't people scream at him to get out?"

"They say he is so kind and charming," her trainer replied, "they appreciate him and don't think he would do them any harm. We don't tell them we think it is a ghost!"

"I still don't think it, but it's a nice story," Summer said.

She really did like the story. Summer would often stare at a portrait of the couple that hung near her station and dream of finding a man like Edward to share life and love with.

Today, a ringing bell summoned her thoughts to the present. Her daydreaming would have to wait. Duty called; supplies needed stocking. Summer let out a long sigh.

It was time to visit the supply room again.

Summer made it a habit of keeping a list of needed supplies so she could get in and out of the dreaded supply room in as few seconds as humanly possible. Perhaps it was the age of the old building, mixed with imaginative thoughts from every suspenseful movie she had ever viewed, but each time Summer went up to the storage room, she went filled with trepidation. She even kept a stash of extra toilet paper behind her station at the desk so she could fulfill patron requests without extra visits to the attic.

When she could not escape a trip to the attic storage room, she tried to distract herself from her dread by thinking of guests at the inn and how perfect accommodations must be for them. However, it seemed the more she focused on these distractions, the more odd things would happen.

At first, it was only the creepy feeling that would enter her mind when she opened the attic door and went up the stairs. Then she realized that no matter how occupied her brain was as she entered the attic door, her arms would tingle and her body would feel strange in the storage room.

She thought if she ignored the awful feeling she had about the attic storage room it would go away. It did not.

Summer was thinking about these things as she placed the skeleton key in the storage room lock and turned it with a click.

When she tried to open the door, it was stuck. This was not a good development. Five couples were going to arrive within the hour, and nothing was ready. She did not have time for the only door between her and a well-stocked house to be stuck.

She pulled hard. The door did not budge.

She ran to get another hostess who was about to leave after her shift.

"Wait! Staci, come up here, please. You have to help me," Summer pleaded.

She was not sure if she was in desperate need of help or if she just wanted company as the eerie feeling began to consume her.

The two women pulled on the door together. One of them even had both feet up on the wall for leverage, but nothing would make that door budge.

Finally, the owner came up the stairs to see what the commotion was about—and why no one was at the front desk.

The two exasperated females told her they would have to get a locksmith or an axe to open the old door that was now sealed shut. The owner sighed and walked over to the door.

"Pity, I do like this old door and the great charm it has," she said quietly.

As she touched the key, the door sprang open. The owner looked at her two employees. They were incredulous. They both knew that door had been stuck only two minutes before.

"Well, let's get ready for our guests," the owner said as she smiled and raised her eyebrows.

After that, whenever the door would stick, Summer learned to say something nice about the home or door, and it would practically open by itself.

Although Summer often felt strange sensations in the attic storage room, she felt the basement was darker than the rest of the house. In most old homes, the basements are dark and gloomy because they are submerged underground. But not in the Woodruff Mansion. It was built on a hill with three sides of the basement above ground. Light easily penetrated the windows.

Every time Summer cleaned a room on that bottom level, she felt as though someone was watching her. One day as she was making up one of the rooms after a couple checked out, she thought she heard them come back down the stairs and into the room.

"Did you forget something?" she called out.

No one responded. Summer turned around. As goose bumps took over her arms, she fought the chill creeping up her neck. No one was there, but she distinctly felt someone had entered the room.

Summer went up the stairs and checked around, but not one soul had returned after leaving the inn. She hesitated and then sat at her desk.

"I am not going back down there until someone else comes in," she said to herself.

Despite her fear of the creepy attic and dismal basement, she could not resist the warm charm and love she felt permeating the rest of the house.

The feeling of warmth was so strong that it drew her to work each day. This was a place she wanted to be. The inn's guests gave Summer a welcome break from her tedious studies, and she enjoyed the girls she worked with— like Staci.

Staci was a cute newlywed who also worked shifts at the Inn on the Hill. Because of her recently announced pregnancy, she was decreasing her hours at work. And she wasn't sure she would keep her job once her baby was born.

Summer and other coworkers were concerned because Staci experienced some complications at the beginning of her pregnancy. However, after the owner insisted she stay at the inn to recoup during her brief, required bed rest, she had regained her health.

Staci always made sure there was fresh coffee and baked treats for the guests. Treats and snacks available on every floor were a tradition at the inn.

Not long after Summer began working at the mansion, she noticed another tradition with guests who stayed in the Colonization suite. The suite

was a large room with a cozy fireplace and small bay window, located on the second floor of the building. Staci told Summer this had been the master suite of the original owners. The lady of the home passed away right in that very room, with her doting husband at her side.

After a night in the Colonization suite, guests would come down to breakfast asking who the gentleman on the staff was.

"He was so kind," they would say. "He leaned over the bed during the night to ask if we were doing all right and if we needed anything."

This story was told so often that Summer began to ask for a description of the man. He was always described as a tall, slender man with light hair and a kind, gentle voice.

Summer began to hear other stories about a friendly man hovering outside the rooms of other guests. She did not know what to think of these common occurrences.

"Staci, what do you make of people saying they have seen Mr. Woodruff?" she asked her coworker.

"Well, he sure sounds like he was a nice man," Staci replied. "If I had to meet a ghost, I hope it would be him."

"The rest of the staff keeps talking about things happening," Summer smiled. "I don't believe in ghosts. There just has to be an explanation."

"You could be right," Staci said. "Strangers check in here all the time or walk in from off the street just to check out the building. Maybe they are just seeing different men who look like Mr. Woodruff."

"I've never seen a ghost and don't want to believe the reports. It sounds like we have an awful lot of tall, thin visitors at this inn," Summer laughed.

The ringing phone interrupted the conversation. When Summer answered, Staci could tell the call was from the owner.

"Oh, that sounds interesting," Summer said into the phone. "Okay, we'll decide."

"A group has been confirmed this evening from the ghost hunters' society," Summer informed Staci. "One of us gets to take care of them."

"What do they want?" Staci responded, looking concerned.

"They want to come meet the Woodruffs," Summer joked. "I guess there are more stories about this place than even we have heard."

"Oh, please don't make me stay here tonight," Staci begged. "Will you please trade shifts? I don't even want to know what they come up with. I'll make coffee before I go," she offered.

Summer took pity on Staci and agreed to stay—mostly because of Staci's pregnant state.

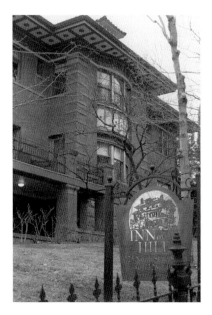

Minnette's bedroom was on the top floor with the bay window. *Nannette Watts.*

"I'll stay, but only if you make cookies, too," Summer said. "I don't think they'll find anything. It is just peaceful around here."

Staci made the coffee but forgot about the cookies. So Summer baked cookies; she laughed to herself as she reflected on her last conversation with Staci.

The ghost hunters arrived right on schedule—late. Summer let them set up their equipment by her desk near the kitchen to get a reading on the building.

She told them they were welcome to the coffee and cookies, but she had work to do upstairs until the end of her shift. Then she vanished.

Not a single sighting of even one ghost rewarded the ghost hunters' vigil. As the minutes passed, their EVP recorded every sound. Still nothing—until they replayed the tape.

While the ghost hunters had been sitting around waiting for something to happen, it appeared the ghosts had been sitting around waiting, too.

"Who made the coffee? It's good," one of the ghost hunters asked.

At the time he asked, no one seemed to answer his question.

But when the tape was played back, a very distinct voice replied, "Staci did."

When the ghost hunters gave their report to the owner and some of the staff, all agreed, "Don't tell Staci!" She did not need to know the ghost knew her name.

As Summer vacuumed the grand stairs during her shift the next day, she thought over the ghost hunter report and other ghost stories she had heard about the inn.

"How could people buy into these stories?" she thought to herself. "How do I explain the voice on the recording saying Staci made coffee? What is it about this house that keeps me coming back?"

A sudden surge of love went through Summer, filling her with overwhelming happiness. The feeling drew her eyes upward, and she saw some motion in the doorway of the room on the left. Silently, she wondered

The Inn on the Hill or Woodruff Mansion, interior stairs. Minnette's room was at the top of the stairs on the left. *Nannette Watts.*

if she had just seen someone from the Zion suite on the right crossing the landing to the Colonization suite left of the stairs.

As she leaned against the opposite side of the stairs, she saw the silhouette of a tall, thin man take the hand of a woman and lift her up as they joined in a warm embrace. The fire was not on in the room behind them, but something must have been casting that shadow onto the door. No one had checked into the room.

Summer knew she had just witnessed a special moment. A smile crept across her face.

She understood the true charm of this old place and what drew her to work every day. It was the same thing that drew so many others to the Inn on the Hill: a deep feeling of pure, devoted love.

Summer cannot explain what happened in that doorway. She still does not believe in ghosts, but she does believe in the enduring power of love. Every time she walks by the door of the Colonization suite, she can almost hear the words, "Are you all right? Do you need anything?"

THE KISSING TREE

361 South 600 East

BY CASSIE ASHTON

The settlement of the Salt Lake Valley was unique. Settlements in the West were established for those who were hungry for adventure, prosperity and the hope of owning property. Salt Lake was different; those who flocked to what would be known as Zion were fleeing religious persecution. The original Utah pioneers wanted the freedom to worship without fear. They did not come as individuals but as a well-organized group.

Brigham Young quickly created communities designed with a centralized grid of a ten-block radius. Each ten-block area was referred to as a ward, and those living in the ward interacted together socially and served one another in both religious and secular activities. The church meetinghouses were the center of activity. Dancing was probably one of the most important social functions for its members. In 1852, Brigham Young had a social hall built so the community would have a place to gather. John Hyde once said, "Mormons love dancing. Almost every third man is a fiddler, and everyone must learn to dance….In the winter of 1854–1855, there were dancing schools in almost every one of the nineteen ward houses." Everyone loved to dance. It was considered an edifying exercise, and even the church hierarchy regularly joined in.

The young people especially loved the dances. It was a place for single boys and girls to meet and for romance to blossom. The tradition continues today. Latter-day Saint singles still gather today to dance and to find true love. What has changed is the place where sweethearts gather for a kiss. In the early days of the Salt Lake Valley, there was a special spot, known as the

The lone cedar tree, a Utah juniper surrounded by brush but no trees. *Todd Martin.*

Kissing Tree, where one would go to steal that first kiss. It was a large cedar tree with far-reaching branches located at the north end of Emigration Road. It was a favorite place for pioneer youth to go after a dance.

In more recent history, the tree became the center of controversy, contention and scandal. Just because it is a good story does not make it untrue. Some stories that seem to be unbelievable because we personally cannot picture or imagine them may still have occurred. Storytellers often make good historians because they allow for all possibilities.

Not believing in possibilities, some historians made a mistake that set off a huge controversy that was unnecessary. They refer to it as the "Lone Cedar Tree Controversy." You can read about it in detail in the 1997 *Utah Historical Quarterly* commemorating one hundred years of the Utah Historical Society.

To briefly summarize, in 1933, because of its history in the valley and due to the fact that it was a favorite meeting spot of the pioneers, the Daughters of the Utah Pioneers memorialized the large cedar tree, the Kissing Tree, with a bronze plaque and columned edifice. The marker states that as the pioneers entered the valley, they found growing near the

Above: Built by Brigham Young in 1852, the social hall stands as a monument to the enterprise and social spirit of the Mormon pioneers. *Marriott Library.*

Right: Kissing Tree monument. *Nannette Watts.*

80

spot a lone cedar tree and paused beneath its shade. They stated, possibly taking some creative license, that loggers and lovers alike enjoyed the tree for their own purposes.

Fast-forward to 1958, when vandals cut down the tree. The event made front-page news, with the Daughters of the Utah Pioneers commenting with outrage and condemning those who did not respect the past and destroyed that which others had tried to preserve. A surprising response came from the director of the Utah Historical Society, a Mr. Mortensen, who basically said it was not such a great loss since the tree was a fraud anyway. His comments and sentiment sparked quite a difference of opinion and division among those who preserved the past.

As the legend of the tree had grown, the term "lone cedar tree" became interpreted as one and only one tree in the valley, but that may not be what was meant. "Lone" typically means solitary or single. Today, thanks to search engines and digitized journals and diaries, we have the ability to see through the eyes of those who were there. Had Mortensen been able to access his own Utah Historical Society records, maybe he would not have

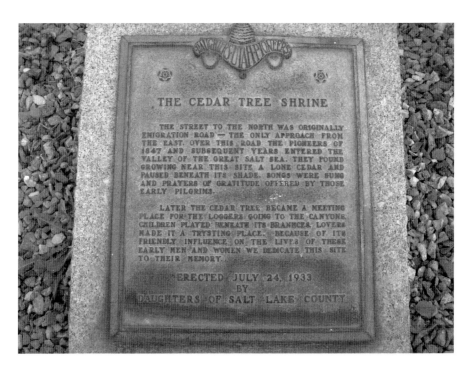

Cedar tree shrine marker, 1933. *Nannette Watts.*

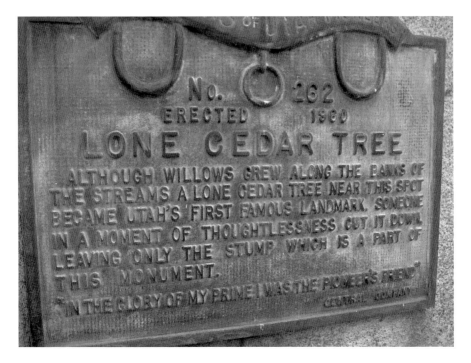

Lone cedar tree marker, 1960. *Nannette Watts.*

been so quick to discredit the tree. In the *Utah Historical Quarterly* 3, no. 3, in 1930 is a personal account from John R. Young, who mentions the tree that was memorialized.

John R. Young wrote a letter to his son: "From our cabin in the mouth of City Creek Canyon, in 1847, one could see a lone cedar tree on the plain southeast of us, and on the south fork of the creek, about where Main and Third South Streets intersect, stood seven, windswept, scraggy cottonwood trees. On the north side of City Creek stood a large oak tree. No other trees were visible in the valley." He went on describing the bleakness of the valley, but it is safe to agree that the cedar tree stood alone and there were not many other trees around. Imagine with what few trees there were, they were friends to the pioneer. Contrary to Mortensen's personal beliefs, some stories that seem to be unbelievable may still have occurred. Things are not always as they seem.

In 1960, a second plaque was added to the spot to explain why the tree was gone and clarify the existence of other trees. The monument is found on the center grass strip at 316 South 600 East. No references exist to

describe how loggers interacted with the tree, but from the account written in Henry Tanner's pioneer journal, the tree was a spot for young men to interact with beautiful girls. We suggest that all those who still have a romantic side take a drive some night and steal a kiss from a loved one just as the pioneers once did.

HENRY TANNER'S AMAZING DANCE

Marilyn Watson loved the new country and valley she called home. She had emigrated with her family from Scotland after reading a pamphlet called *Remarkable Visions*. It told a story of a young boy searching for truth. As a family, they had sought for truth as well and found the answers they were seeking in the Church of Jesus Christ of Latter-day Saints. They wanted to join the other Saints in building a new kingdom of Zion and made the long voyage from Scotland to the United States. They joined one of the first wagon trains going west. Salt Lake City was now home.

They had sold everything, taking only what was absolutely necessary to make such a long journey. Marilyn had pleaded with her father to be able to take her favorite dress. She loved it. It was made of soft cotton. It was lavender in color with a small printed flower on it and a scoop neck outlined with a ruffle. The skirt was full and twirled when she spun around. She had a matching shawl, and she felt beautiful when she wore it. The dress wasn't practical, but it was necessary. Father complained that it wasn't a work dress and she wouldn't have time for socializing. Mother had stepped in and reminded Father that a nineteen-year-old girl will always find a little bit of time to socialize. Mother had prevailed, and Marilyn was grateful as she twirled around in her lavender dress.

Marilyn loved Friday nights. It was the end of the week, and Brigham Young had counseled the Saints that they should put down the plows and tools and gather for food, music and dancing. Music filled the ward hall as fiddlers picked up their bows and called everyone to the dance floor. Marilyn loved to dance. The boys loved dancing with her as well. She was considered about the best dancer in the valley. She was light on her feet and moved easily and quickly. She always had a smile for everyone. It wasn't long before her nickname became Lavender to match the dress and shawl she wore every week.

The Tanners arrived in Salt Lake in 1859. It was amazing to see the progress that the city had made in just ten years since entering the valley.

The city had a delightful rhythm. Everyone worked hard and played hard. Henry had recently returned from preaching the gospel, and his mother reminded him that it was about time he settled down. She wanted him to find a nice girl and get married. He wasn't sure he wanted to get married, but he liked the idea of finding a pretty girl to spend time with. He loved to dance and soon found himself attending every dance around.

The one thing Henry hadn't found yet was a girl he wanted to take to the cedar tree. The boys who attended the dances would often offer their charming dance companions a ride home via a "roundabout" way. This allowed them to try for a hug or a kiss or a promise for future meetings at a spot all the youth knew as the "Kissing Tree." The tree was a short ride east of town. On July 24, 1860, one year after he came to the valley, Henry Tanner attended what would be the most exciting dance of his life—exciting in a way he could never imagine or truly explain.

The July 24 dance was always the best-attended dance of the year. It was a day of celebration called Pioneer Day, commemorating the Mormon pioneers' arrival to the Salt Lake Valley. Henry was amazed to see how many beautiful young girls were at the dance. It was crowded. He danced with several girls, and then one in particular caught his eye. She was the most beautiful girl he had ever seen. She was obviously popular with the boys and danced every dance. And what a dancer! Such graceful maneuvers Henry had never before seen. She had an infectious smile that never left her beautiful lips, and she wore an attractive dress, light purple in color—the color of lilacs in bloom—with a matching shawl.

Finally, Henry saw his chance and asked her to dance. She was quiet but seemed to enjoy his company. They danced together until the social ended. He asked if he could drive her home in his horse-drawn buggy. She smiled and nodded shyly. Even with her shawl, Henry could tell she was cold in the night air, so offered her his coat, which she accepted. He placed it around her shoulders. He became a bit bolder and asked if she would like to take a long way home, which meant a drive by the Kissing Tree. She smiled, blushed and nodded again.

Henry drove to the tree, talking a great deal along the way to keep up his courage because he wanted more than anything to kiss this beautiful girl. He hadn't had much experience kissing girls, so he was nervous. When they arrived at the Kissing Tree, it was late and the night had become cold. Not to be deterred, he stopped. Gazing into her eyes, he mustered up his courage and gently kissed her lips. They were soft and tender. Never before had Henry felt such bliss. Before he could try for

another, it started to lightly rain. As a gentleman, he knew he should get her home quickly.

"Where do you live?" Henry asked. It was close. He drove his buggy briskly in the direction she pointed. Eventually, they came to a lane at the southern end of town. She pointed to the home at the far end. He couldn't see the house; it had no lights on inside, not even a candle or a lamp.

"Thank you," she said and hopped down from the wagon and dashed off into the darkness. He would have helped her down, but she disappeared so quickly. He wanted to stop her. He didn't want to let her go. But she was gone. He drove home, remembering the softness of her lips. It wasn't long before he fell asleep, dreaming of the beautiful girl he met at the dance.

The next morning, Henry awoke with a smile on his face, thinking about Marilyn once more. *How soon can I see her again?* He thought about her all day. He didn't want to appear too bold, but he wanted to see her again, today. Then he remembered, *I was so transfixed by her, I completely forgot about my coat! I placed my coat around her to keep her warm. Retrieving my coat is the perfect excuse to go see her without appearing to be too forward.* Henry saddled his horse and rode toward the house where she lived.

Things looked different in the light of day. Henry thought he had the right street, but the house at the end was deserted looking and probably had been for a long time. The front yard was completely covered with weeds. It wasn't in good shape. He wondered if he was in the right area. *This can't be right. I must be mistaken. Perhaps it was a different street…but no, surely this was the right one, and this was the right house, except that it is empty…abandoned.*

Perplexed, Henry knocked on the door of the closest neighbor. "Does a pretty girl named Marilyn who wears a lavender dress live in the last house at the end of the lane?" Henry inquired.

"Lavender?" questioned the old man who had answered the door. "Yes, to be sure she did. But you don't seem old enough to have known her," came the reply.

"Known her? What do you mean?" asked the very puzzled Henry.

"Because," answered the man, "Lavender died ten years ago of pneumonia. It was the winter of 1849. She was about your age then, just twenty years old. She was a real beauty—the best dancer in the valley. She had a beautiful smile, she did. Every boy fancied her. They were good people, worked hard. Her family came from Scotland. She only had the one good dress, with a matching shawl, both of a lavender color. She didn't even live long enough to get her a new dress. That's how she got her nickname, 'Lavender,' 'cause of the dress she always wore. You can go visit

her. She's buried up in the city cemetery, under the poplar tree at the far east end. You can't miss it."

Henry was incredulous. He could not believe what he was hearing. He could not think of what else to do, so he rode his horse up to the east end of the Salt Lake City Cemetery. There he found a poplar tree, under which was a headstone. It read, "Marilyn Watson" and below the name "Lavender," along with the date she was born and the date she died—ten years earlier, in 1849.

But the eeriest thing he saw, which made the hair on the back of his neck stand on end, was that there, folded neatly on the grave, was his coat—the coat he had wrapped around the shoulders of the beautiful girl with whom he had danced the night before.

Who was she, where was she, what was she? He would never know. He picked up his coat and quietly returned home.

CHAPTER 9
MASONIC TEMPLE

650 East South Temple

BY NANNETTE WATTS

It was early 1920, and Freemasonry was growing in Utah. The nondenominational service organization needed a new hub and headquarters, as it would soon outgrow its building. The new building would be the seventh and final home of Freemasonry in Utah. Carl W. Scott was the architect for the job. He caught the vision of the world's oldest fraternity. This new Masonic temple would need to have facilities to support men's, women's and youth organizations—the whole Masonic family.

Scott began to dream of the new building, and he dreamed big. Each angle of the Masonic temple would be symbolic inside and out. Those who walked in would be reminded of the charge to make good men better. Each step climbed toward the entrance should remind them of their journey and the need to advance. An Egyptian motif was perfect to highlight yet conceal the ideas of self-improvement and learning.

The plans were shared with increased excitement when the added symbols of light and life above the doors were noticed. Three doors were included; north and south entrances would have to do, even though the north entrance would be on the darkest side of the building.

The temple would be guarded by two sphinxes carved from Utah granite. Each would sit pondering a sphere it held. Even those who did not belong to the lodge would understand the power and strength reflected in these symbols.

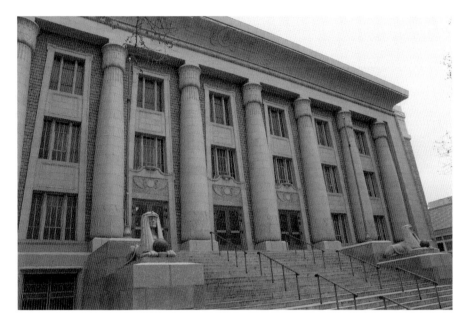

Sphinx guard the Masonic temple. Some say they will tell your fortune. The receptionist says, "No, they don't talk. They're made of stone." *Nannette Watts.*

Masonic temple exterior front, 2017. Lights above the door are known to flicker independently. *Nannette Watts.*

The third exit on the west would not be used as often. It was the funeral exit and usually kept closed. Tradition held it would open symbolically for a Mason's funeral cortege. The door's scarab symbol could separate, signifying a break in the lifespan of a master Mason. Good standing members were entitled to a Masonic funeral, if the family requested. The funeral processions offered there were to be high honors of a life well lived by a master Mason.

The Masonic temple was to represent each phase of the progression of a Mason, from his beginning awareness to the very end.

LARRY MEETS CHARLIE

Larry Fairclough was impressed. He knew the Job's Daughters dance would be fun, and the fully lit up Masonic temple did not disappoint. It was imposing.

He hurried up the steps, anxious to dance the night away with his main squeeze, Linda, a cute Jobie.

As Larry entered the hall, the place was abuzz with lively excitement. He soon found his girlfriend, and they began dancing to their favorite music—song after song. When the room became too hot from endless dances and overheated bodies, the two went to get some punch and cool off. They discussed music with the other kids and why some of the newest songs could not be played at the dance.

On one side of their circle of friends, Larry overheard a conversation begin. Two girls looked concerned.

"I don't know if we should," one of them said.

"Oh, it's okay," chided one of the boys. "You'll have us to protect you. We've seen him."

"You mean you've really seen him?" the girls cried.

"Well not exactly, but we've experienced him. Come on!"

The group of friends turned and hurried out of the room. Linda grabbed Larry's hand, and they followed.

They made their way stealthily toward the stairs and ran up the first flight to the landing. Then, turning, the group crept up the next flight. They wandered through a foyer area and down a hallway. "What are we looking for?" one of the girls whispered.

Her question was met by a unified, "Shhhh!" from the others in the group. They took five more slow steps down the hall and then—BAM!

A door slammed at the end of the hall, sending the group's screeches, yelps, howls and finally laughter in every direction. Teenagers were scurrying, seeking the safety of the chaperones below. Everyone had to admit it was a fun dance, made even more exciting by the quest to find Charlie.

If that had been the only Charlie experience he'd had, Larry would have thought it was just someone sneaking ahead to slam the door. But all through high school, he had heard stories from youth DeMolay and Jobies telling about experiences with the ghost, Charlie Valentine, making banging sounds and mysteriously turning lights on and off in the Masonic temple. That night at the dance, Larry had no idea he would cross paths again with the Masonic temple and Freemasonry—and Charlie.

Throughout high school, Larry kept busy by working in construction. The experiences from work and the intelligence he gained from school clicked. He began his own construction company at age nineteen while attending Westminster College.

When he was twenty-eight, Larry joined the Fraternity of Freemasonry. He progressed and was raised through the beginning degrees of Masonry within months—right there at the Salt Lake City Masonic Temple.

Masonic temple interior, 2018. *Nannette Watts.*

During those months, thoughts of Charlie crossed his mind and he continued to hear of experiences people had with the trickster ghost, but he never had any of his own.

One day, a fellow Mason filled him in on Charlie's story. He told him, "Charlie has been dead since the late 1920s or early '30s. He spent so much time at the lodge when he was living that his widow said, 'Send him back there,' when he died."

"She did?" Larry was aghast.

Charlie's widow wrote a letter to the Grand Lodge stating that she did not want his ashes sitting around the house on a mantel. The letter sounded pretty frustrated.

"Since he spent so much time there in life, let his ashes sit around there," Charlie's wife wrote.

No one is sure if she even held a memorial service in his honor.

Charlie's ashes held a prominent place on a mantel for a while before being retired to a bookcase. Then they were stowed on a storage shelf until someone could figure out what to do with him. The ashes were forgotten, and that is when a man fitting Charlie's description began to appear in the temple.

Some wives would love to know their departed husband was back. Charlie's wife just stayed mad at him for spending so much time here in life and refused to come visit. He had not followed the instruction given to Masons that family and profession are to come before the duties of a Mason. Perhaps it shows why he was so happy here though.

Strange and unexplainable things began happening in the different lodge rooms and auditorium. Lights turned on and off and doors opened and closed. A friend who was alone in the temple late one night after an activity said the furniture began to move without any help.

"So there you have it," Larry's friend said, "your official introduction to Brother Charles Valentine."

Although Larry participated at the lodge for years, he still saw no sign of Charlie. But he was soon to make a closer connection with the ghost.

He helped his newly married niece and her husband, Trina and Ray, apply for the job of night watchman. Their newlywed budget was in dire need of the rent-free basement apartment that went with the job.

On the third night in their new home, after Ray had finished his rounds and locked up, they heard banging noises and saw lights turning on by themselves. Ray and Trina were spooked, so they called the police.

"Hello, I would like to report a break-in," Ray said.

"Excuse me, what city are you calling from?" the voice on the phone interrupted.

"Salt Lake City, Utah," Ray replied. "I'm in the Masonic temple on Second South. Someone has to be in the building with us right now. Please hurry!"

"I'll put you through to dispatch," was the reply.

"Hello, this is Officer Branch," a new voice said.

"Yes, hi," Ray said. "I'm calling from Salt Lake City, and I think someone broke into the Masonic temple."

"What makes you think someone broke in?" Officer Branch asked.

Ray could not believe what he was hearing.

"I'm in the building," he responded. "I'm the night watchman. I just finished my rounds checking the locks and turning off the lights. As I finished, some of the lights came back on, and there are banging noises coming from one of the levels. Could you please send an officer over?"

The officer let out a long sigh. "You must be a new night watchman, eh?"

"Yes, this is my third night," Ray said.

Ray could hear the officer's smile as he responded.

"Well, we know the Masonic temple pretty well," he said, "and we usually get calls like this from the new night watchmen about this point in their job. How about you call us back when you know someone is in the building with you for certain? We'll send a patrol car to check the perimeter of the building as soon as we can."

Ray hung up the phone, stunned. He did not want Trina to go into danger, but she insisted on going with him to check the building.

"I will not stay here while you go search by yourself," Trina told him.

Ray hugged her and could feel she was trembling. They searched the building but could find no sign of an intruder.

The next morning, first thing, Ray talked to Dave, the day manager.

"Do you know what happened last night?" Ray asked.

"Uh oh, let me guess," Dave responded. "There were…uh, lights or banging noises. You called the cops, but they didn't sound interested."

"How did you know?" Ray answered in a monotone. "Listen, Dave, you didn't tell me this would be part of the job."

"Look, I'm sorry I didn't prepare you better," Dave laughed. "But just know what to expect and you'll be fine."

"But what if I hear glass shattering?" Ray protested.

"Glass shattering, eh?" Dave said. "I'd look into that. All other banging is probably just Charlie."

Ray never got past the fear those late-night sounds drove into his heart. Perhaps he could have gotten used to the sounds alone, but the added effect of doors he had locked unlocking on their own and lights turning on by themselves was just too much. Charlie always found a way to startle them. It got so bad that he and Trina would just close down the building when the noises started and give Charlie free reign.

The couple gave it a go for five years while they saved their money. They moved out in 1985, leaving another couple to have fun, character-building experiences.

Finally, Larry met Charlie himself, two years after Ray and Trina moved on to quieter quarters.

In 1987 on a Sunday evening, Larry was serving as chapter dad for Salt Lake's chapter of DeMolay. He was working with the youth to put on *A Knight of Comedy in Relief*, a Monte Python play that would serve as a fundraiser for the Masonic Temple Association.

Everyone had gone home but Larry. He was in the main hall, tidying up before he gathered his things to leave.

Suddenly, the chairs began to flip. It was as if someone was walking down a row, flipping four of the chairs as he went. From where he was standing, Larry could not see anyone. The initial sound startled him, but Larry did not feel afraid.

"I know I walked everyone out and locked the door," he said to himself. "I am the only one in the building."

"Did someone get locked in and want out?" he called.

There was no answer. Larry walked out into the hallway to check. There was no one.

He was very sure he had locked the doors after everyone left. As he walked back into the room, he knew he was not alone.

"Hey, we're just trying to raise money to support this place," he called out again.

Larry locked up and went home. Charlie could have the place to himself.

He turned the event over in his mind all the way home. What would have upset Charlie so much? Could it be that Charlie is a good religious man and didn't approve of the kids rehearsing on Sunday? He had made his statement.

During a major cleaning and renovation in 1985, Charles Valentine's ashes were found on a shelf in a storage room. Bob Raymond, the grand secretary, shared his excitement with Larry.

"Now we have proof that all of those stories floating around all these years are true. The remains of Brother Charlie were, in fact, sent back to the Masonic temple."

"What are we going to do with them?" Larry asked.

"I don't know," Bob responded. "I have checked every source I can, but I can't even find when Brother Charlie was a member here or which lodge he was part of. I've searched."

Without any other details, the ashes remained on the shelf. Brother Larry had seen them.

In 1993, Larry became grand master of the Grand Lodge of Free and Accepted Masons of Utah. He began to wonder if Brother Charles Valentine had been asking for help to be laid to rest at last.

The fraternity owned some plots over at Mount Olivet Cemetery. The cemetery was filled with trees and rolling hills—a serene place to rest. Larry asked the Wasatch Lodge No. 1 to take care of the service and the burial.

"Please make sure Brother Charlie has a lovely memorial service and see that he feels celebrated," Larry requested.

The ceremony was held, and the west doors were opened for the master Mason's funeral cortege. They laid Charlie's ashes to rest, thinking that might be the end of their resident ghost.

Things were quiet for eight months, but people kept telling stories about Charlie. The Masonic family missed him. Brother Larry felt melancholy.

"Have I done the right thing?" he asked himself. "It seemed improper to have him just lying around here, especially in a storage room. But this was the place that made him happy. *He* was happy here, and everyone was happy with him being here. I wish I hadn't done it. If only we could go back."

Charlie's grand entrance elevator. *Nannette Watts.*

Just when everyone thought Charlie was finally resting in peace, during a busy time at the building, the elevator seized up. It froze solid and would not move. Someone ran to find Grand Master Larry. The secretary called the elevator repairman.

"Hi, yes, we need to schedule a repair of the elevator at the Masonic temple," the secretary said. "The trouble? Well, it is stuck. It won't move. A bright light is…what? Yes, a very bright light is bleeding through the crack of the elevator doors."

The elevator repairman thoroughly checked out the elevator.

"I'm sorry, Mr. Fairclough," he told Larry. "I can't find anything wrong with it. I don't even know what that bright light would be. Does anyone have any idea what they were doing before it seized? Will any kids come forward and admit what really happened here?"

A large crowd had gathered while they talked, and the light in the elevator shone with a wild brightness. The elevator doors released their bond and opened, as the light inside seemed to explode and fade to normal.

Master Larry smiled as he contemplated Charlie's dramatic return to the Masonic temple.

The Masonic temple west doors used for a Mason's funeral procession. *Nannette Watts.*

Charlie's active periods at the temple fluctuate on and off these days—just like the lights he plays with. Perhaps he has gained even more light and knowledge from all those extra years at the Masonic temple. Perhaps he has even found his wife and let her know she really is his first priority. Whatever has become of Charlie, the Masonic family is content anytime he returns to pay them a visit.

CHAPTER 10
McCUNE MANSION

200 North Main Street

BY CASSIE ASHTON

The McCune Mansion is positioned on a hillside in the Marmalade district of Salt Lake, nestled between the imposing capitol building and the majestic Salt Lake Temple. At the turn of the twentieth century, most of the wealthy and influential elite in Utah built their homes along Salt Lake City's Grand Boulevard–South Temple. Elizabeth McCune was tired of living at the Gardo House, which was along the Boulevard. She wanted a place of her own. Alfred, her husband, was happy to grant her heart's desire. She wanted to gaze upon the temple daily, so they left the Boulevard and spared no expense in building one of the most illustrious homes in the city. The McCune Mansion is a three-story, twenty-one-room bungalow-style mansion comprising twenty-one thousand square feet. Elizabeth used the finest-quality woods, marbles, tiles, silks and tapestries from all over the world to construct it. She even had the large ballroom mirror shipped in one piece from Germany. The house has had a variety of occupants, but its beauty and structure have remained timeless; very little of the house has changed over the years.

The McCunes lived in the home for twenty years, entertaining, working and raising a family. They wanted to downsize, and instead of selling their beloved home, they decided to donate the mansion to the Church of Jesus Christ of Latter-day Saints to benefit as many people as possible. It became the McCune School of Music and Art for fifty years. Next, the Virginia Tanner Modern Dance School used it, and finally, Philip McCarthey purchased it in 1999, renovating and updating it. Since then, it has been

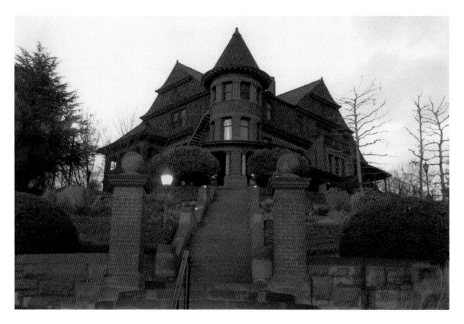

McCune Mansion external, front facing. *Nannette Watts.*

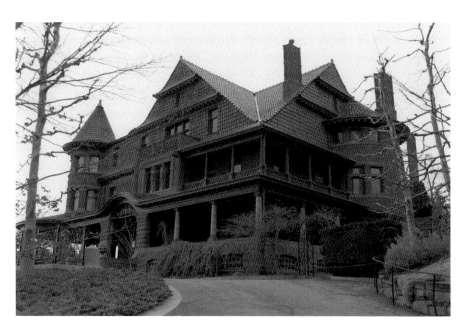

McCune Mansion external driveway, side facing. *Nannette Watts.*

known as the McCune Mansion, Salt Lake City's premier wedding and business event center. The McCune Mansion event center motto is "to provide a historic treasure which embodies fine taste, gracious hospitality and superb service," with the unwritten promise of so much more.

The mansion seems to have a very dreamy quality about it. It was no surprise when *Brides* magazine voted it one of the Top 50 Romantic Wedding Venues in the United States in 2013. When you are there, you feel like you have been transported to a different world, or maybe the truth is, a different world resides in the mansion. It could easily also show up as one of the Most Haunted Wedding Venues in the Nation. It is good to know that if you host an event at the mansion, you may encounter some additional items that are not advertised.

Poltergeist at the Wedding

Rebecca loved being a wedding planner. She was excited to land this new account. The bride wanted an elegant, fairytale wedding, held at one of the city's most romantic wedding venues: the McCune Mansion. She made an appointment with the events coordinator at the mansion to spend the day observing a wedding. She had never worked with the venue before, and she always made a habit of becoming familiar with a new venue before the event.

Rebecca entered the mansion and was greeted by Sandra, the mansion's event coordinator. The place was a buzz of busyness. A florist was putting the finishing touches on her arrangements that filled the room with the sweet scent of roses and jasmine. A cake had been delivered and was being assembled. The chef was busy ordering staff around. There would be a formal dinner, and the tables were being properly set. Sandra took a deep, satisfied breath as she gestured across the dining room and commented to Rebecca, "Isn't it such an elegant setting?"

"Aaaaaaaahhhhhhhh!" The peaceful moment was disrupted by a loud, long scream. Rebecca followed Sandra as she quickly moved toward the terrifying noise and collided with Colleen, an employee at the mansion.

"What is wrong? What are you screaming about?" asked Sandra. Grabbing Sandra's wrist, Colleen dragged Sandra into the drawing room. Rebecca followed and saw the spacious drawing room walls accented with impressionist paintings. One was a large picture of young ballerinas all

dressed in white. The girl in front, perhaps twelve or thirteen years old, was on her toes. Across the room on the west wall was a full-size wall mirror.

Colleen pointed at the large mirror and stammered, "I was lighting the last of the candles and dimming the lights when something caught my eye. I turned my head and watched a young girl in a flowing white dress come out of the mirror!" Shaking, she repeated, "She came out of the mirror and then disappeared. I looked around the room trying to see where she went. She was gone. I could swear that it was the same girl in that picture there." She pointed to the large mural of the ballerinas. "The one with blond hair. It was her, I swear."

"Okay, sweetie," Sandra said, as she pulled out a chair, "why don't you just sit down for a second and take a deep breath. I am sure the lights were just playing tricks on you. I am going to go get you some water." Looking toward Rebecca, she said, "Please excuse me a moment" and walked out of the room.

Rebecca stood there looking at Colleen. "Hi," she said, "I am Rebecca, a wedding planner. I am planning a wedding that will take place here in a few months, so I thought I would check things out. Did I hear you correctly? Did you say you saw a ghost?"

The drawing room in the McCune Mansion. *Nannette Watts.*

100

"Yeah, I think I did," Colleen said, shuddering. "I don't want to believe in ghosts or see ghosts, but I really don't think it was the lights. It happened so fast, but it was real. Something was there!"

Wanting to comfort her, Rebecca reached over and patted her shoulder. Sandra returned with the water and quickly interjected, "Well, it is gone. Take a few minutes, breathe deeply and then finish what you need to. I'll continue to show Rebecca around. Oh, and by the way, where is the feather pen for the sign-in table? I thought you said you set it all up."

"I did, a little while ago—the book, the pen and flowers. They are all there. Why? Are you saying it is missing?" Colleen asked with an agitated voice.

"Well, yes, I guess it is," Sandra responded. "But don't worry; I'll find it. I am sure it is nothing."

"Nothing, nothing!" Colleen burst out. "You know exactly what it is! You act like it is nothing, but something moves things in this building. This place plays tricks on people." Colleen looked at Rebecca. "I am not making this stuff up. Strange things happen here."

Sandra interrupted, "No one is saying you are making anything up. I believe you. In the beginning, I thought it was just stories that other venues whispered to drive away business. I never really believed it when people said that the best part of a reception here is what goes on unseen. But it doesn't change the quality of the weddings we produce."

"Alice," Sandra said quietly, as though speaking to herself and her unseen guest, "go back through the looking glass and stop spooking people. Weddings are not the time or place for you to show up."

"Umm, this is really awkward," Rebecca interjected. "How do I plan a wedding around a ghost? Do you really think this place has a ghost? How many are there? What stories have you heard?"

"I don't, or didn't, want to believe there are ghosts," Sandra replied, "but the evidence is beginning to pile up. Why don't we go sit down in my office and enjoy some of our signature lemonade. I will fill you in as best I can."

Once they were comfortably situated in Sandra's office, she began her story. "When I first got here, I heard a story about Phil McCarthey," Sandra said, "the man who renovated the house. It had taken two long years of renovations to bring back the splendor of the McCune Mansion. But it was worth it. It was breathtaking. He was pleased. The wood floors shined again. The ornate ceilings were impressive with the detailed workmanship. The marble fireplaces shined and were huge and imposing. It seemed extra special since it was Christmastime and all gorgeously decorated. The family

The third-floor ballroom in the McCune Mansion. *Library of Congress.*

had decided to celebrate the holidays at the mansion. They had decorated a Christmas tree to celebrate the holiday festivities; packages were everywhere, the kitchen was full of pleasant aromas. Phil was calling the family together when he looked up and saw the ballroom lights were on.

"He called his two teenage daughters, 'Girls, run up to the ballroom and turn off those lights. We don't need to leave lights on all over the house.' The pitter-patter of four feet could be heard ascending the stairs. There was a long silence. Then giggles were heard, along with some banging and then the sound of feet running down the large staircase. The girls returned, bewildered. 'Dad, the light switch doesn't work. The lights won't turn off. It is creepy. We can't figure it out. You come and see if you can get them to turn off.' 'Oh, my goodness,' McCarthey said in exasperation. 'How hard is it to turn off some lights?' He climbed out of his recliner and headed up the grand staircase. He flipped the switch, but nothing happened. He tried all the switches, but the bank of four lights stayed on. He tried them again. 'What is going on?' he wondered. 'Why can't I turn these lights off?' Looking

up, he caught a glimpse of Alfred McCune's portrait. Perhaps Alfred was thinking something like, 'Here before me stands the great-grandson of Thomas Kearns, my rival in politics. Now he is trying to claim my home as well. He'll think twice about changing my house.' Phil smiled to himself; he was tickled. He finally hollered out, as if in surrender, 'Okay, Mr. McCune, you win!' The lights flickered but stayed on. No matter what he tried, Phil could not figure out how to get the lights to shut off, so he left them on. After Christmas was over, he had an electrician come to the house to fix the problem. Mr. McCarthey discovered that the ballroom light switch was two floors below the ballroom. No one in the McCarthey family knew that, but it could easily explain how the lights were manipulated. But who did the manipulating? The McCartheys had their suspicions. It seemed they were sharing it with the previous owners."

Rebecca was strangely fascinated. Her mind started putting the pieces together. "So you think one of the ghosts may be Albert McCune?" she asked Sandra. "What about his wife, Elizabeth?"

"I don't know who the ghosts are. I'm still not sure if I believe in ghosts. I can only share what I have heard. To answer your question, those who work in the kitchen think that Elizabeth is there. Chris, the chef, has spent years here. He always teases that you enter the kitchen at your own risk. He says the best part of his job is training new assistants—not because he particularly enjoys repeating and teaching the routine of the kitchen but because he loves to watch the newbies during their first encounter with her, the ghost. One of Chris's favorite stories is about Sally's first day.

"Sally was excited to be working at the mansion. She called it her dream job. Chris was orienting her to the kitchen, explaining the layout and flow, when all of a sudden there was a loud *bang* as a pot came crashing to the floor. Sally jumped. The pot had slipped from its overhead hook. No one else seemed startled. One of the crew just bent down, picked it up and put it back. Sally's heart was beating faster and faster as she considered the possibilities. She was not paying much attention as Chris rambled on. She was still trying to calm her nerves and focus her eyes. It looked like things were moving all by themselves. Was she the only one who could see what was going on? Finally, she could hold back no longer. 'What is wrong with you guys?' Sally asked in dismay. 'Didn't anyone else see that bowl move down the counter? Or that ladle move by itself?' There was true panic in her voice. The group burst into laughter.

"'Yes, we saw it,' Chris replied calmly. 'We were just waiting to see if you would admit to seeing it. I loved your reaction. Welcome to Elizabeth's

Alfred and Elizabeth McCune. *Marriott Library.*

kitchen,' he continued. 'She likes to help us cook—or at least she keeps us company while we cook. You will get used to our helpers, but if you are uncomfortable with the supernatural, then you may not like it here.' Sally looked relieved. 'I can handle the supernatural,' Sally said. 'I just don't like feeling crazy. As long as I am not the only one seeing things, I will be just fine.' Chris reassured her that she was fine and welcomed her aboard."

"Is there really that much activity in the kitchen?" Rebecca asked as Sandra finished the story. "Chris claims there is," Sandra replied. "I stay away from kitchens as much as I can. Food does disappear from time to time. But other than noise, things moving and disappearing, it is fairly quiet."

"So, Alfred and Elizabeth are here," Rebecca said. "There was a ballerina coming out of the mirror. Are there any other ghosts?"

"Probably," Sandra said. "I think there are also some musicians."

"So, you do admit that there are ghosts," Rebecca probed.

"Well, not exactly," Sandra said. "But let's just say I haven't found another explanation for the music that comes from the walls.…Let me explain."

"I was in my office working late one night, wrapping up some paperwork. Everyone else was gone. It was quiet and peaceful, and I was getting a lot done. Then, slowly, the sounds of an orchestra began to seep through the walls. It sounded like a chamber orchestra. It was a bit odd and eerie.

"I decided maybe I was tired and it was time to head home. I grabbed my purse and headed for the door. But the faint sounds of string instruments being played continued. It bugged me. I wanted to find out where the sound was coming from. I knew there had to be a simple explanation. I figured it was a radio or boom box that had been left on or turned on. I tried to follow the sound, but it was as if the music was coming from the walls. I went to the kitchen and found nothing. I went upstairs to the ballroom and found nothing. I came down the stairs and went into the big hall and again—nothing. I was feeling anxious as I searched and searched but found no electronic device emitting the lyrical sounds. The sound was the loudest around the stairs, but I saw nothing that could be creating it. Then I remembered the secret room under the stairs. I opened the door. Nothing. It was empty. I shut the door. I figured I must be beyond exhausted. I turned off the lights and headed for the door. It was quiet; the music had stopped."

Rebecca was riveted and asked, "What was in the secret room?"

"Nothing," Sandra replied. "It is just this odd little room, like a secret hideaway. I did hear once that when Elizabeth McCune would host a dinner party, she would have a chamber orchestra play in that room and the sound would go throughout the whole house. I guess it was the first surround sound."

"I wonder if some of those musicians still hang out there?" Rebecca asked.

"Maybe," Sandra replied. "This place was a music school for a long time, too. Maybe students secretly practiced in there and still do. Who knows? But I do know that the walls make music."

The main staircase in the McCune Mansion. *Nannette Watts.*

Colleen popped her head in the office. "I am feeling better now, and the wedding party is arriving," she said. "We have to get to work." Rebecca stood up and extended her hand. "Sandra, I really want to thank you for letting me spend some time here at the mansion," she said. "I appreciate getting a feel for its charm and character. This really is a marvelous place. I am glad I'm alert to the possibility of uninvited guests; it will keep me on my toes and add that little extra magic. As long as we don't have to pay extra for them, I will make sure they are welcome."

She and Sandra stood up and walked into the hall. "I don't think I will let my bride-to-be know of all the extras that come with this venue," Rebecca continued. "Let's keep it our secret." She looked around in awe and excitement.

"I can see already that this is going to be a most memorable occasion," she said. "Thank you. I can't wait to see what happens."

The mansion continues to host the most romantic, beautiful and memorable events. If you enjoy the unexpected, you may think of having your next big event there as well.

SALT LAKE CITY CEMETERY

200 N Street

BY KRISTEN CLAY

In the bottom of the wheelbarrow lay a naked corpse. Nearby was a bundle of clothes concealed in the bushes.

Fact is truly stranger than fiction when one considers some of the bizarre history surrounding the Salt Lake City Cemetery in the 1860s. With death being one of the only certain things in life, a cemetery was certainly one of the first things the early Mormon pioneers needed to establish upon arriving in the Salt Lake Valley. In 1847, George Wallace laid his young daughter, Mary M. Wallace, to rest on a beautiful hill overlooking the valley on one side and the Wasatch Mountains bordering the other. When community and church leader Brigham Young asked George to choose a city cemetery site, George knew just the right place. He brought an appointed council to his daughter's grave. Upon experiencing the peaceful locale and breathtaking view, they immediately set aside three hundred acres to be used as the city cemetery. George Wallace was then engaged as the first record keeper and sexton of what is now the Salt Lake City Cemetery.

Currently, there are 130 rolling acres with nine and a half miles of roads. The Salt Lake City Cemetery has become a destination for both locals and people from across the globe to visit. While artists, historians, nature lovers, genealogists and tourists find the history and setting of the cemetery a great place to enjoy, contemplate, create and mourn, over 123,000 famous, infamous, colorful and beloved individuals call this hallowed location their final resting place.

Salt Lake City Cemetery entrance main gate, designed by Fredrick Hust as part of a competition. He won thirty-five dollars for his design in 1915. *Library of Congress.*

The early days were not always kind to the cemetery set on a hill. Water was scarce, and the first few attempts to build wells were futile. The cemetery was rocked by scandal only a decade after incorporation. One of the first grave diggers, Jean (John) Baptiste, a Venetian immigrant, who had arrived in Salt Lake City by way of Australia, was the center of the disgrace. The macabre deeds of Baptiste might have gone unnoticed if it hadn't been for another ignominious story taking place at the same time.

Scandal

Abraham Lincoln was in the White House. The nation was engrossed in the Civil War. Second Territorial Governor of Utah Alfred Cumming wanted to get home to Georgia before Civil War lines were impassable. Wanting to keep an eye on the growing number of Mormon settlers, the federal government was in immediate need of appointing a new territorial governor.

Lawyer, farmer, newspaperman and loser of multiple bids for public office John W. Dawson of Indiana was selected. His number one qualification:

Indiana wanted to get rid of him and the Utah Territory was about as far as one could go and still be in the United States.

Arriving in Salt Lake City on December 7, 1861, he did not do much to endear the god-fearing residents to him. Not only did he arrive with his mistress, but he also voted against Utah becoming a state and sent a letter to the United States legislature proposing that Utah be taxed $26,982 annually to fund the Civil War. Brigham Young is said to have referred to Dawson as a "jackass."

The last straw was when Dawson made lewd and inappropriate advances toward young widow Albina Williams, who chased him out of her house with a fireplace shovel. He proceeded to offer her $3,000 to keep quiet about the assault and then threatened to shoot *Deseret News* editor Thomas B.H. Stenhouse if he published anything regarding the situation.

On New Year's Eve, three weeks after his arrival, he disgracefully boarded a mail coach back east. Stagecoach driver Wood Reynolds happened to be the nephew of Albina Williams. No longer able to endure Dawson's bragging about his sexual exploits, Reynolds waited for him to fall asleep at the Ephraim Hanks Stage Station in Mountain Dell, Utah. Along with a few other cohorts, he beat John Dawson within an inch of his life. Dawson dispatched a letter to the *Deseret News* detailing his assault and naming the culprits, one of whom was Moroni "Roni" Clawson.

Meanwhile, back in Salt Lake City, Albina Williams had sent an affidavit describing Dawson's "insulting behavior" in detail. This caused a minor sensation in the U.S. Senate. A letter to the *People's Press* of Bluffton, Indiana, said of Dawson, "He is a poor, despised and hated ruffian, without a solitary friend of any influence on earth, outside of his own printing office. This is not the first time that [a] community has been sickened and disgusted with the infamy and crime of John Dawson."

Local leaders felt Dawson's shameful exodus from the territory to be sufficient in dealing with his grievous conduct. Although he was indeed "despised" by most, the brutal and unlawful attack on him was considered unacceptable, and the ruffians involved were rounded up and arrested. This was the Wild, Wild West, and in keeping with the reputation of the times, a gunfight broke out between the outlaws and the law. Three of the outlaws were gunned down, including Moroni Clawson.

All three deceased were taken to the Salt Lake City Cemetery, and since no one claimed the bodies, they were to be buried in the potter's field. Several weeks passed, and upon hearing of his brother's death, George

Clawson came to claim his brother's body and have it moved to the family plot in what is now Draper.

Accompanied by Sheriff Henry Heath of the Salt Lake police force, George had his brother's body exhumed. Upon opening the coffin, George was dismayed at what lay before him.

"I know my brother has been accused of being in all kinds of trouble with the law, but this is no way to treat anyone!" he exclaimed.

Sheriff Heath glanced into the open coffin in dismay. He was dumbfounded by the sight before him: Moroni Clawson was stark naked! He appeared to have been tossed into his coffin like a rag doll.

Salt Lake City Cemetery's last wooden headstone in the pauper section, 2012. *Nannette Watts.*

"I witnessed his burial myself; I even bought him a brand-new suit with my own money," Sheriff Heath countered.

In disgust, George demanded an investigation, threatening to sue if answers were not forthcoming. Of course, an investigation was immediately initiated. Sexton Little was bewildered as to what might be going on. He suggested that they pay a visit to Jean Baptiste because he might be more informed as to the goings-on of the graves.

Suspicion of the grave digger Jean Baptiste arose after Sheriff Heath paid a visit to his home. Baptiste's wife, who was described as "feeble-minded," sweetly invited Heath and his small delegation into her home. As they inquired where her husband might be found, they noticed an excessive number of boxes piled around. A nonchalant glance into one of the open containers triggered shock: a "motley sickening heap of fresh-soiled linen" and "funeral shrouds" was hoarded within.

Surveillance was planted around the cemetery, and soon Baptiste was observed pushing a wheelbarrow from a maintenance shed toward an open grave. In the bottom of the wheelbarrow lay a naked corpse. Nearby was a bundle of clothes concealed in the bushes.

Remembering back on the incident years later, Sheriff Heath wrote:

I at once charged him with robbing the dead and he fell upon his knees calling God to witness that he was innocent. The evidence was too strong and I choked the wretch into a confession when he begged for his life as a human being never pleaded before. I dragged him to a grave near my daughter's and pointing to it inquired: "Did you rob that grave?" His reply was "Yes." Then directing his attention to the mound of earth which covered my child's remains, I repeated the question with bated breath and with the firm resolve to kill him should he answer in the affirmative. "No, no not that one; not that one." That answer saved the miserable coward's life.

Baptiste was taken to the Salt City Jail, where, for his safety, he was put in solitary confinement. News of his crimes spread quickly, and fellow inmates were ready to string him up, as they recognized the clothes he was wearing—a "broadcloth Prince Albert suit"—which belonged to a saloonkeeper who had recently died and had been buried wearing it only a few weeks previously.

When the police returned to Baptiste's house, the full extent of his gruesome deeds came to light. They found clothes of the dead throughout his home. Curtains and furniture slipcovers were made from burial clothes. The cellar contained a large vat that he had used to boil the clothes of the dead who had died from contagious diseases. Boxes of men's, women's and children's shoes were discovered, along with jewelry and watches.

Heartbreak

The articles of clothing and jewelry were taken to Washington Square (the future site of the City and County Building) and laid out on tables for the public to claim on behalf of their deceased. Any articles not claimed were put into a coffin and buried back at the Salt Lake City Cemetery. It was estimated that he robbed over three hundred graves. He only confessed to robbing about a dozen in fear that the families of his victims would come after him and kill him.

Mormon pioneer Jesse Wentworth Crosby reported a family incident with the grave robber while he was away. In his journal, he wrote about his wife, Hannah, going and identifying the clothing of two family members, including those belonging to her fourteen-month-old daughter. With her heart broken a second time over her loss, Hannah chose to have

the bodies disinterred, redressed and reburied. A friend of the Crosbys stated, "This affair is the worst, the lowest, the meanest, the blackest crime I ever heard of."

The news of the grave robber's gruesome deeds caused such an uproar that family members were rushing to the cemetery to disinter loved ones at an alarming rate. The commotion was such that Brigham Young was compelled to address the issue over the pulpit. Explaining his decision to leave his departed family members resting in peace, he assured the Saints that their loved ones would come forth in the resurrection fully clothed. This appeased the masses insomuch that they ceased unearthing their relations. With time, the cemetery's tarnished plots began to heal.

The anger toward John Baptiste, however, did not dissipate. A mob gathered outside his trial and the jail. Frontier justice was demanded. Although territorial leaders could not allow a lynching, they knew justice needed to be served. They decided that the best punishment to fit the crime would be exile. Baptiste's crimes made him unworthy to live among society.

Study the past or enjoy the present at Salt Lake City Cemetery, 2012. *Nannette Watts.*

West of Salt Lake City lies the Great Salt Lake, the largest saltwater lake in the United States, with an area of roughly 1,700 miles and eight main islands of varying habitability. This seemed to be the perfect solution: banishment to a barely habitable island. Freemont Island, only accessible by boat and used as a cattle post, was selected.

A wagon, with the pretense of delivering dairy supplies, was backed up to the jail. John Baptiste was slipped in the back and, unbeknownst to the mob, was carted off first to Antelope Island over the sandbar and then to Freemont Island by boat. Left alone on the island with only cattle and wildlife as his companions, a few supplies and a small shelter, Baptiste was to commence his sentence of isolation.

About three weeks later, a group of men was dispatched to check on him and deliver supplies to the island. There was no trace of John Baptiste, only what he left behind: the carcass of a heifer whose hide had been tanned and a partially dismantled shelter. It appeared he had fashioned together a makeshift raft in an attempt to escape his sentence of seclusion. It was assumed that he drowned or otherwise died in his attempted escape. It was reported he was not seen again after his exile.

Or was he?

Hauntings

In recent years, many individuals have reported seeing a man carrying what looks to be a wet bundle of clothes and sometimes a shovel along the south shores of the Great Salt Lake, as well as on Antelope Island. Others have reported an orb on their cameras and video cameras in the same locations as the sightings.

One couple driving along the road near the Garr Ranch on Antelope Island described seeing a pitiful man walking along the road.

"Maybe we should stop to see if he needs assistance," the wife said.

As they drew nearer to him, the hair on the backs of their necks stood up. They were both filled with a sense of dread.

"Something's not right," the husband replied, shuddering. Feeling the need to get away, he pressed on the gas.

"But what about the man?" she exclaimed. Shifting in her seat to look out the rear window, she gasped, "Where did he go?"

He was nowhere to be seen.

"Stop, turn around!" she pleaded.

"Are you insane?!" her husband retorted. "Didn't he give you the creeps?"

"Yes, but he might need help," she argued.

"Fine," he reluctantly agreed. "But make sure the doors are locked," he said, turning the vehicle around.

Retracing their route and carefully scanning the roadside and beyond, there was not a soul to be seen.

SALT LAKE CITY'S B'NAI ISRAEL CEMETERY

"Emo, Emo, Emo," they would chant as they walked backward, holding candles or lighters, sometimes with eyes closed. One, two, three times around the alluring monument they would go. Hoping to get a glimpse of a spirit from beyond, they would end their macabre "Ring Around the Rosie" by glimpsing into the wrought-iron opening of the tomb of Jacob Moritz, also referred to as Emo's Grave.

The memorial of Jacob Moritz in 2012. His ashes were moved due to vandalism and occult activity. Solid metal now closes the opening. RIP, Mr. Moritz. *Nannette Watts.*

This grave is located on the main road of the B'nai Israel Cemetery leading directly from the B'nai Israel gates, which always remain locked.

One man reported participating in this bizarre ritual as far back as the 1930s, when he was young. But if asked "Just who is Jacob Moritz?" most people could only answer with a guess.

JACOB MORITZ

Born in Bavaria in 1849, Jacob Moritz finished his education in business in Mannheim, Germany. At age seventeen, he decided to seek his fortune in America. He first arrived in New York City in 1866 and secured employment with brewing company F.&M. Schaefer. Then, he moved on to St. Louis, where he worked at Anheuser-Busch. After gaining valuable brewing experience, he moved to Helena, Montana, in 1868 and dabbled in mining.

Utah was quickly becoming a crossroads and offered a savvy young businessman like Moritz many opportunities. He moved to Salt Lake City in 1871 and started the Montana Brewery. He then formed the very successful Salt Lake Brewing Company in 1883. His brews won many state fair medals. He became the largest exporter and most successful brewer in the West. He boasted capping six thousand bottles a day. He also ran thirty-six saloons and doggeries.

As wealthy socialites, he and his wife, Lahela, became involved in many philanthropic causes. Members of the B'nai Israel congregation, Jacob served as president and vice president and Lahela was a leader in the Hebrew Ladies Benevolent Society. After the 1906 San Francisco earthquake and resulting fires, Moritz filled an entire train car with goods and sent it off to help victims of the disaster.

A member of the constitutional convention, Moritz helped pen the Utah Constitution. In 1902, he ran against fellow congregant Simon Bamberger, a railroad man also known for philanthropy. The election was heated. Bamberger was well known for his sense of humor and built the well-loved Lagoon amusement park along the mid-line of his railroad. Meanwhile, Moritz was receiving some bad press in a temperate state regarding some of his saloons. The newspapers' handling of the elections increased political tensions. One Salt Lake newspaper called Moritz a "poisonous jimsonweed" and referred to Bamberger as an "oak tree." Bamberger was the only Democrat in the city to win the election. Bamberger went on to

become the first Jewish governor of Utah and the third Jewish governor in the United States.

Jacob's health began to fail in 1909. He and his wife, hoping that a change of scenery and rest from his labors would improve his health, sailed for Europe. "I've worked hard for twenty-six years without hardly a day's rest. Don't you think I'm entitled to one now?" he jested with Lahela. Upon the advice of specialists, they sought a cure in the baths of Wiesbaden, Germany. But alas, it was there at the German resort that he succumbed to cancer of the stomach only six months later. Surrounded by his wife and siblings, he died in the country of his birth.

The *Salt Lake Herald*, reporting his death and lauding his life, stated, "In the death of Jacob Moritz Salt Lake loses a man who for many years has

Jacob Moritz (1848–1910), successful businessman, brewer, philanthropist and activist. He is buried in the Congregation B'nai Israel Cemetery, aka Emo's Grave. *Utah Historical Society.*

been prominent in business and political affairs. His acquaintance extended over the entire state, and he was held in the high regard and esteem by all who knew him." The *Salt Lake Tribune* extolled his character, reporting that he "never betrayed a trust" and that he had built a fortune, "not a single dollar of which was dishonestly gained."

Lahela returned with his ashes to Salt Lake City and laid him to rest in the B'nai Israel Cemetery portion of the Salt Lake City Cemetery in 1910.

EMO'S GRAVE

How Moritz came to be called Emo remains a mystery. How the legends around his crypt began one can only guess. Visits to Emo's Grave can be traced back to the 1930s. A man in his mid-seventies attended a ghost tour in 2002 and told the guide that he would visit Emo's grave as a boy with his friends.

One theory (favored by Story Tours) about why Moritz might rise from his grave goes back to the political rivalry with Bamberger. In 1926, Simon Bamberger died and was buried directly across from Jacob Moritz.

As the legends of Emo became well known, more and more pilgrimages were made to the grave. With time, some of the tales took a dark turn. The practice of occult activity began to take place on and around the grave, vandalism became more rampant and the beautiful black marble vessel that once held Moritz's ashes was destroyed. His ashes were moved to an undisclosed location in the cemetery with the hope that he could finally rest in peace. The cemetery staff also placed a piece of sheet metal in the opening, sealing it off to those who would leave unappreciated tokens. Has Jacob Moritz found the rest and peace he sought when his life was cut short, or is being a workaholic a habit just too hard to break?

"My grandma sees ghosts…and so do I," the eleven-year-old girl announced as she tapped the guide on the shoulder at the beginning of her ghost tour before blending in with the rest of the group.

Just before dusk fell upon the B'nai Israel Cemetery, the city lights were barely starting to turn on. The group gathered in front of the tomb. MORITZ was clearly emblazoned along the top of the monument to a great man. Although it was still light out, imaginations were spurred by the curiosity of an iron door embossed with the letter M encircled by a leafy design under a wrought-iron window of sorts. Inside the window, a beautiful black marble vase once held the remains of Jacob Moritz. Now, all that remained were a few pieces of marble, hardly recognizable for what it was.

The guide called the group to attention. All eyes were on her as she told the story of Jacob Moritz, his rise as a business leader, his electoral embarrassment, his service to the community and at last his death. She pointed directly across from Moritz's tomb to the grave of his political rival, Simon Bamberger. Could being situated for eternity across from his political adversary be the reason of his apparition materializing? Whatever the reason, nine decades of individuals describe a similar phenomenon: a face, often with glowing eyes, looks out from the wrought-iron bars.

Anticipation swelled in the guests as they were invited to reenact the ritual of Emo's Grave. With a candle in hand, one brave volunteer walked backward, guided by her friend. Once, twice, she circled the tomb. Nervous whispers and a chuckle or two could be heard as she chanted, "Emo, Emo, Emo." The third time around, she glanced into the darkness of the tomb.

Emo's glowing eyes. *Dana Denton.*

"I see something!" the eleven-year-old called out to the guide, pointing to the opening in the tall stone structure. The guide smiled and acknowledged her. No one else seemed to give the child much heed.

At the same moment, a camera clicked.

The brave volunteer peered inside, letting out a shriek and giggling.

"Did you see anything?" her friend pressed.

"No," she replied with disappointment in her voice.

"I saw something!" the eleven-year-old insisted.

"Whoa, check this out!" A woman holding the camera hollered, ran over to the guide and pushed her camera in front of the guide's face. "I got it! I think this is what she is talking about."

The guide, along with the others, stared at the screen in disbelief. Right where the little girl had pointed, a pair of eyes, hot and white, glowered out from the darkness of the crypt.

"That's what I saw!" Validated, the girl reiterated, "I told you I see ghosts."

CHAPTER 12

SISTERS OF THE HOLY CROSS HOSPITAL

1050 East South Temple

BY NANNETTE WATTS

T wo miners stood up from where they were taking a break in the crisp June mountain air. Each man rubbed his eyes. Were they really seeing what they thought they saw?

Two nuns in black habits climbed the last of the hill leading to the camp, followed by a St. Bernard; fitting. They, like those in many other mining camps, thought they had lived to see everything.

As was their habit, the Sisters of the Holy Cross checked on the welfare of the miners while explaining the meaning of their visit. Father Scanlan saw the need for sisters to come establish a school in the city. There were only ten Catholic families in the area currently, but with all of the mining and railroads, he anticipated the need would grow.

The year 1875 seemed a tough time to raise money. The sisters had been to visit religious leader Brigham Young. While he could not assist the sisters, he encouraged them with such kindness that they were convinced they could accomplish the goal.

The sisters explained they were visiting every mining camp in the region to ask for support and monetary donations. Sister M. Augusta and Sister M. Raymond impressed the miners. They opened their hearts and their billfolds to the women.

They quickly had all they needed to build the school. Upon arriving or leaving, the sisters had to explain their furry companion. The dog followed

The old and new together: chapel and hospital, former Holy Cross Hospital until 1993. *Nannette Watts.*

them everywhere. He belonged to the Marshalls, a Catholic family with whom the sisters would live until their quarters were built.

One repeated request from miners was that the sisters open a hospital in addition to the school. Sister Augusta agreed. She had experience from serving in a military hospital in 1861, during the Civil War. She took care of soldiers from both sides and was known as "the soldiers' friend." She was determined to become the miners' friend too.

The needed $25,000 was raised in three months. Five more sisters arrived by August. Sister Augusta remained true to her promise and rented a small brick building to serve as the hospital. There were twelve beds and a great need. Sisters began sleeping on the floor to make room for patients.

A new hospital opened in 1883 with 125 beds, and there was another expansion in 1950. The Holy Cross School of Nursing opened in 1901 and operated for 72 years. Over its 132-year history, 1,400 sisters served in Utah. Their influence is felt to this day.

Sisters of the Holy Cross. *Marriott Library.*

Holy Cross School of Nursing, courtesy of Sam Weller's Books. *Nannette Watts.*

THE NUNS CAME BY

Jake walked up to Elliot's desk looking pale.

"Man, you look like you've seen a ghost," Elliot joked.

Jake looked serious.

"Dude, don't," Jake said. "I was standing in the break room and felt someone standing over me. When I looked, no one was there."

Garrick and a coworker joined them as Jake was telling his story.

"Hey, I've felt that in the break room, too," Garrick said. "Have you had families of patients who stay in rooms 117 and 118 talking about interesting things happening in those rooms?"

"Room 118 is definitely haunted," Elliot affirmed. "One Christmas, we only had four patients, and there were two nurses on duty. The lights kept going on at the end of the wing that was closed. The call light kept going off in room 117, but no patient was checked in there."

Garrick's coworker took a deep breath.

"I'm a good Catholic girl," she said. "I don't have to worry about those ornery old nuns…"

She gasped and clasped her hand over her mouth "…unless they are listening!"

She and Garrick broke into laughter.

"It's like you were back in school for a minute and worried they were going to crack you on the knuckles," Garrick laughed.

"Exactly!" She let out a sigh of relief.

Elliot's eyes widened—a signal that he had a story to tell.

"You guys are so funny," Elliot said. "I can usually tell which patients or their family members have gone to Catholic schools—at least those with experiences like yours." Elliot winked.

"Often when I go in to take vitals, patients tell me how they are just fine because 'The nuns came by.' I always try not to meet their gaze and just ask, 'What do you mean?' The nuns have come in to offer a drink to someone who is thirsty or an extra pillow to someone wanting to be propped up more.

"'The nuns were very nice and helpful,' the patients always say. 'They just didn't talk very much.'

"I have a hard time telling people the nuns haven't been here since they sold the hospital in 1993.

"I've worked here for eleven years," Elliot said. "It was cooler before they did the remodel of the old East Wing. There was much more activity then.

In the old building, I used to see nuns flash by, and people would always see shadows of the nuns.

"The sisters are still busy with their work, but since the remodel, occurrences are less frequent.

"If you want to ask about regular ghostly activity, go talk to Beverly in labor and delivery."

The three friends left Elliot to his work and walked down the stairs to ask Beverly about her ghostly experiences in the hospital.

"Yes," Beverly told them, "there are ghosts who are nuns—sisters who used to serve in the hospital.

"I have no doubt there is a nurse ghost in room 8," Beverly said. "She is nice when she visits. I have no problem sharing the labor and delivery department with the helpful ghosts, but don't ask me to go to materials. That's our glorified hospital supply store or storage room located in the bowels of the hospital.

"It has a door connecting it to the morgue," Beverly said, shuddering. "You can tell if an autopsy is being performed because the doctor plays classical music very loud while he's doing one.

"Try being in materials in spooky silence when, suddenly, the music begins to blare," Beverly laughed. "First it scares you because you're in a creepy place. Then it scares you back out of your skin when you realize what he is doing just through the door."

The ladies continued to talk, but Garrick and Jake went back to find Elliot.

As the guys rounded a corner, a large man stepped out of a doorway. They both jumped. They all laughed as they recognized Bill from security.

"You two look like you actually believe in all those ghost stories floating around," Bill scoffed.

"Don't you believe them?" Garrick asked.

"Haven't you had any of your own?" Jake questioned.

"Look," Bill preened, "in my business, there isn't a place for being scared. People start telling stories about things that can be very easily explained. But when someone suggests a ghost is behind what happened, everyone goes along with it.

"Take the chapel, for instance; people say things happen in there all the time. They are just hearing noises from the apartments underneath it.

"I will admit there is something worth looking into in recurring tales, though."

Jake and Garrick were ready to hear the story.

"When I was a thirteen-year-old boy in eighth grade back in 1968, I broke my collarbone. Have either of you ever broken a collarbone? It's the worst pain you'll ever feel in your life."

"I had to visit the emergency room right here at Holy Cross, only the ER used to be on the southwest corner of the building."

"You mean ER used to be where materials and the cafeteria are now?" Jake interrupted.

"Yes," Bill said. "The cafeteria's been there since 1973. Before that, it was a pretty gruesome end of the hospital. When you know what used to be there and what it is now, it's pretty easy to see why people come up with ghost stories."

"Why do you think an old ER would cause people to tell ghost stories?" Garrick asked.

"Just the nature of the beast," Bill continued. "A lot of things exist in folks' imaginations. I've worked security here for thirty-four years, and I've never had an experience myself. I do have to admit that when at least six people tell the same story, it does make me think there has to be something going on over there."

"I've never heard any stories about the cafeteria wing," Jake said. "What kind of stories are you talking about?"

Bill walked them down to the cafeteria, and they sat at a table as he shared the story of what six people he knew had reported.

Patrick was working in the cafeteria storage room. He saw some movement and thought a coworker was in there with him. He was lifting some heavy boxes onto a storage shelf, and one began to slip.

"Hey, Therese!" he called.

He could see the back of her blond ponytail, but she did not turn around. He tried again.

"Therese, can you give me a hand here?" he called.

When she did not respond, he shoved the boxes onto the shelf and went to see where she was. She was gone, but he got a cold feeling as he walked over to the area where he had seen her.

Patrick left the storeroom. Therese was in the cafeteria wiping down the salad bar.

"Why didn't you come help me when I called?" Patrick asked.

"What do you mean?" Therese asked. "I've been right here cleaning the salad bar the whole time you were in the back."

That's when Patrick said he noticed that Therese was wearing her hair down and did not have it up in a ponytail.

"Five other people had the same kind of story about seeing 'her' in the storeroom. Ellie saw the lady through the columns of the room. She thought she looked quite young—fortyish, dressed in white with her blond hair in a ponytail.

Left: Weeping statue in the haunted rose garden at Holy Cross Hospital. *Nannette Watts.*

Below: Monument to Sisters of Holy Cross on 100 South. *Nannette Watts.*

"Here's another one for you. The cooking staff reports a different lady in the back tunnel—a nun. None of the staff will go alone on a garbage run because they all get scared in the hallway to the tunnel.

"Some say there was a nurse who was escorting a psych patient. They were at the top of a metal winding staircase located above the tunnel that connects the nursing school building with the hospital west wing. Apparently, the psych patient pushed the nurse to her death. Her head hit the metal grate at the bottom so hard that it still has an indentation to this day.

"The cafeteria staff swear the dead nun is the ghost haunting the tunnel that leads to the garbage bins. The tunnel is dark and has a gloomy feel. No one wants to run into her in that lonesome passageway. Strict nuns are scary enough, but a dead nun is terrifying.

"So, I guess you could say I have to give some credence to reports of the tunnel ghost because enough people have told me about their experiences. But I wouldn't go so far as to say I believe it's actually ghosts. I think most everything can be explained away."

Bill stood to leave.

"Well, gentlemen, have an excellent evening. It's back to work for me."

Jake and Garrick also stood to leave. By the time they arrived back at Elliot's desk, they had turned Bill's stories over and over in their heads. They asked Elliot if he had heard the stories about the tunnel ghost and the old ER wing.

"Oh, and he debunked your theory that things happen in the chapel," Jake said. "He said people must be hearing sounds from the adjacent apartments."

"But remember," Elliot said, "people say they *see* things in there. I've never heard a story from there that included sounds."

The light began flashing in room 118. They all stopped. Elliot broke the silence.

"Don't worry," he said. "It's empty. The nuns will take care of it."

126

CHAPTER 13

WHISKEY STREET COCKTAILS AND DINING

323 South Main Street

BY KRISTEN CLAY

There are spirits around here, and not just the kind you drink!

Mormon pioneer settlers longed for their utopian ideal in the West. After fleeing extreme persecution, they worked for a decade to build their dreams in peace. The self-sufficient, agrarian society they built based on their religious ideals began to shatter.

Colonel Albert Sidney Johnston led his army into Salt Lake City in 1858. The transcontinental railroad with its vast web of lines ended the Mormon community's isolationist existence. Silver was discovered, and a new type of pioneer came seeking their fortunes, hoping to strike it rich in the mines. With all of this, the Mormons' sheltered existence was cracked by the influence of the "Gentile" interlopers.

Saloons and doggeries began to pop up most dominantly on Main Street. At one point, over forty-seven such establishments took up a two-block section of the street. By 1859, this stretch of Main Street was commonly referred to as Whiskey Street. With the passage of time, brothels would be found on the top floors and speakeasies were hidden or not-so-hidden in the basements.

The first establishment built at 323 South Main Street was the Deseret Lounge. Not much is known about the affairs of this outfit. A theater eventually filled the space.

In October 1911, the Shubert Theatre, taking over the Lyric Theater, opened its doors with a comic opera. In theater lore, it is considered lucky

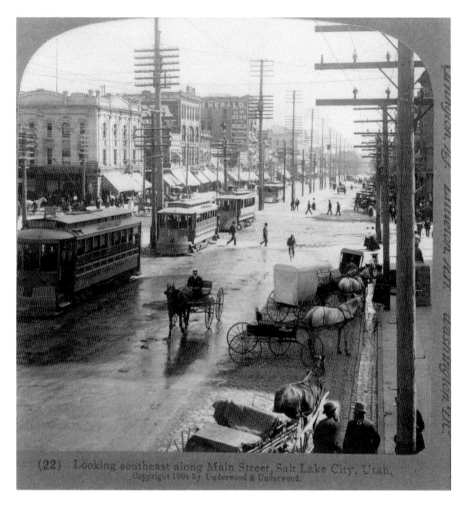

(22) Looking southeast along Main Street, Salt Lake City, Utah.
Copyright 1904 by Underwood & Underwood.

Looking southeast on Main Street in 1904, nicknamed Whiskey Street by Brigham Young due to the many saloons and doggeries. *Library of Congress.*

for a theater to have a ghost. Just how haunted the building was at that time is unknown. In considering whether this theater had any luck, it depends on which perspective one views. Just over two years after opening, the Shubert was ravaged by a fire.

Eleven individuals had a close call with death in the theater. The Baker family lived in the theater, as Mr. Baker maintained the building. The building was fully engulfed in flames and part of it had collapsed by the time Mr. and Mrs. Baker realized what was happening. The smell of smoke aroused them from their sleep. Two firemen, while being sprayed with water by the

firemen outside the building, smashed into the theater's living quarters just as the family of seven was waking. In the heat of the moment, the firemen threw quilts around the mother and children, ages seven months to thirteen years, and carried them down the stairs and out onto the street. In true theatrical style, the crowd that had gathered outside burst into enthusiastic applause as the firemen reached safety with the family.

Three firefighters were injured when the south wall of the building collapsed. Three other men in the adjoining building barely escaped with their lives. When the wall collapsed, people started shouting that three men had died. Unbeknownst to the crowd, a young messenger boy knew that the men lived in the building. When he had seen the flames shooting into the air, he rushed in, aroused them from their slumber and saved their lives.

The fire was known to have originated on the stage but was due to mysterious circumstances. According to the building's tenants, the locks were unreliable. Tramps and vagrants were known to sneak in through the back door and sleep on the stage. They were unofficially blamed for the fire.

Shubert Theatre after the fire, 1912. View of Main Street through the ruins of the proscenium arch. *Marriott Library.*

The newspapers reported that if any "tramps were killed, their bodies have not been found in the ruins."

A new structure was built on the theater's ashes. The Rotisserie Inn, a French-Italian restaurant, was run by two childhood friends from Italy. Cesare Rinetti and Francisco "Frank" Capitolo came to Salt Lake City by way of New York, where they worked at the Ritz-Carlton gaining valuable expertise. The duo offered Salt Lake City an elite new culinary experience. Their newspaper ad boasted: "The best and promptest service combined with all of the delicacies to be obtained in the local and foreign markets properly prepared, constitute some reasons for the high class patronage we are enjoying. No cabaret, no orchestra, but perfect food and service."

They quickly gained acclaim both locally and around the country. The Rotisserie Inn became the favorite eatery of visiting celebrities and dignitaries, as well as the local cream of the crop, from 1915 to 1957. There were whisperings of mob activity being carried on both in and around the vicinity during the Rotisserie days.

For the next several decades after the Rotisserie's closing, the building experienced vacancies and turnarounds. The longest occupancy was the Berndt Norman Jewelry store.

WHISKEY STREET TODAY

The lightning storm that had lit up the Wasatch Front for most of the afternoon and evening had finally ended. The electricity lingering in the air was still palpable. Story guides Kristen and Nannette had spent the evening on Whiskey Street. They were re-interviewing the workers and patrons in the many businesses within a three-block stretch to add to and update stories for the ghost tours.

More than once as they walked along the street or entered various establishments, they could feel the "spirits" brewing. A strong presence was felt in the basement of a nightclub, and another specter could be felt looming in front of a historical building. Little could they imagine what was in store for them this ominous September night.

Wanting to get home before the "haunting hour," they decided that their last interview would be at Whiskey Street Cocktails and Dining.

They stepped into the current establishment and took in the ambiance of old Whiskey Street. To the right, a beautiful wooden bar and oak backbar

An homage to the past, Whiskey Street welcomes the living and the dead. *Nannette Watts.*

lined with various amber-colored spirits greeted guests. A narrow building with booths along one wall and bar-height tables down the center contributed to a cozy atmosphere. On any given day, this picturesque ode to the old frontier life finds itself packed with locals, tourists and ghosts.

The manager shared the latest hauntings, which Nannette scribbled in her notebook. The gracious staff was more than willing to share their experiences with the many inhabiting spirits.

A bartender told of a regular patron who always sits at the long bar. One evening, whiskey in hand, the man gestured to the top ledge of the backbar and asked, "Where is she?"

Eyeing the man and second-guessing his sobriety, the bartender inquired, "Who?"

"The little girl who runs along on the ledge up there kicking the bottles off," the patron replied, sounding perfectly rational.

"That explains everything!" the bartender later shared. Bottles would seem to "randomly" fly off the top shelf. The little girl must have some manners because she would choose only the "empties" to topple over, and she would never hit anyone directly. Apparently, the unseen (by most) little girl has a favorite bartender whom she loves to taunt. Whenever her favorite bartender is working, objects will fall near him. On one occasion, a large phone directory slowly started to inch out of its place on the shelf. Wide-

eyed, the bartender watched it slowly wiggle out until it fell and landed right next to him.

Many employees suspect their numerous ghosts to be connected to the Rotisserie Inn tenure. One of the managers, Frankie, will often hear his name being called when he is the only one around; one of the original owners of the building was named Frank.

They have experienced a great deal of paranormal activity in the kitchen.

"Who spilled the beans?" The chef was irate when the staff came into work one day. "I had an entire pot of chili cooking on the stove, and now look!"

The entire industrial-sized pot of freshly made chili was splattered all over the floor. His rage was heightened by the fact that nobody would admit to the misdeed. With a final threat to fire the culprit, he viewed the security footage. He could not believe his eyes! He called the staff over to verify what he was seeing: the pot was slowly sliding inch by inch by itself off the stove until it crashed to the floor. Everyone is a critic, even the ghosts.

Other annoying happenings in the kitchen started to make sense now. They did not have an irresponsible employee dropping things, leaving them for the next staff to clean or misplacing things; they had a poltergeist! No blame is cast anymore when a mess is discovered; rather, security footage is viewed and the invisible culprit identified. In the walk-in freezer, they will observe things "fly" off the shelves.

It looked like a crime scene; a blood-red splatter was dripping down the wall as they walked into the kitchen to start food prep for the day. Video footage showed a bottle of Sriracha sauce being knocked off the shelf, flying across the room and shattering on the opposite wall.

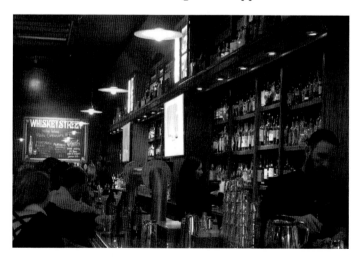

Many "spirits" are found inside Whiskey Street Cocktails and Dining. An apparition of a young girl runs along the ledge knocking bottles down onto unsuspecting bartenders. *Nannette Watts.*

"The creepier ghosts are in the back. The fun and tame ones are in front. The creepiest ghost wears a trench coat and stands in the corner of the bar just looking at everyone," a longtime employee explained.

A server was getting ready to set up for the day when she heard a sound in the front of the building near the window. She looked up just in time to see a chair fly off the top of a table and land perfectly on top of another chair. Another server, as he was cleaning up for the night, saw a garbage can being flung down the hall. He yelled, and it reversed directions and came back toward him.

One night, a patron returned to the dining room from the restroom at the back of the building appearing pasty-faced and shaken. When asked what was wrong, she replied, "Did you know there was a murder back there?"

"Why, what happened?" her server asked.

"I had the strangest feeling. There is a very strong presence in the back of the building. I know that there was a murder. I could just feel it."

On more than one occasion, patrons using the restroom have returned to their tables with reports of feeling a presence there. Some will see shadows moving in the men's bathroom. A patron once described seeing a "high-class" man with dark hair wearing a 1930s-style tuxedo looking at him in the mirror. When he tried to get a closer look, the well-dressed apparition vanished.

The story guides shuddered at some of the stories and thanked the employees for sharing them. Both women had a long drive home, one to the north and the other to the south end of the valley. With this in mind, they determined a pit stop to the ladies' room before leaving was a must.

A typical busy evening for the bar, tables were packed as the pair made their way to the back of the narrow building where the facilities were located.

"Excuse me, pardon me," Kristen smiled and nodded to fellow patrons, as she bumped into people and furniture en route to the back corridor leading to the bathroom.

At the exact same moment, both women froze. Chills ran up their spines as they looked at each other and simultaneously proclaimed, "Right here!" The domains of malevolent and benevolent ghostly inhabitants were clearly defined; they had just stepped across the threshold to the creepy side.

However, "when ya gotta go, ya gotta go!" The women were not to be deterred from reaching their final destination: the bathroom. Nannette reached for the door and pulled it open, and the two stepped inside. Both feeling unsettled, they resolved to hurry. Engaging in rapid small talk, the two attempted to ignore the unnerving atmosphere.

A stereograph card showing Main Street, Salt Lake City, Utah, in 1871, aka Whiskey Street. *Library of Congress.*

Kristen stepped out of her stall first and continued to chatter at the sink while washing her hands. *Smack!* Someone distinctly whacked her on the behind. Incredulous, she turned, thinking it must have been the door that bonked her. The door was firm in its closed position.

The hair on her arms began to rise, and she paused, still in disbelief. Looking around once again and shivering, she called to Nannette, who was still in the other stall. "Umm, Nannette, umm, something or someone just slapped me on the behind; I think we need to go," she stammered.

As a "woman of a certain size," the story guide is still trying to figure out if she should be frightened or flattered. One guest, upon hearing the tale of the butt-spanking spirit, said to the guide, "Both! No 'butts' about it. You should be both!"

BIBLIOGRAPHY

Books

Church Educational System, ed. "The Utah War." In *Church History in the Fullness of Times*, 368–79. Salt Lake City, UT: Church of Jesus Christ of Latter-day Saints, 1989.

Crosby, Samuel Wallace. *Jesse Wentworth Crosby; Mormon Preacher-Pioneer-Man of God.* UT: self-published, 1977.

Hyde, John. *Mormonism: Its Leaders and Designs.* New York: W.P. Petridge & Company, 1857, 119–20.

Lester, Margaret. *Brigham Street.* N.p.: Utah State Historical Society, 1979.

Malmquist, O.N. *The Alta Club, 1883–1974.* Salt Lake City, UT: Alta Club, 1974.

McCormick, John S. *The Gathering Place: An Illustrated History of Salt Lake City.* N.p.: Signature Books, 2000, 140–44.

Sillitoe, Linda. *A History of Salt Lake County.* N.p.: Salt Lake County Commission, 1996.

Wharton, Gayen, and Tom Wharton. *It Happened in Utah.* N.p.: Two Dot, 1998, 54–58.

Journals

Gates, Susa Young. "Elizabeth Claridge McCune." *Utah Genealogical and Historical Magazine* 16, no. 1 (January 1925): 1–13.

Johnson, Brandon. "One Building's Life: A History of Salt Lake City's Denver and Rio Grande Depot." *Utah Historical Quarterly* 78 (Summer 2010): 196–217.

Topping, Gary. "One Hundred Years at the Utah State Historical Society." *Utah Historical Quarterly* 65, no. 3 (Summer 1997): 265–75.

White, Jean Bickmore. "Gentle Persuaders: Utah's First Women Legislators." *Utah Historical Quarterly* 38, no. 1 (January 1970).

Young, John R. "Reminiscences of John R. Young." *Utah Historical Quarterly* 3, no. 3 (1934).

Magazines and Newsletters

Damron, Paul Edwards. "The Pioneer Home of Milo Andrus in Crescent, Utah, 1858." *Andrus Recorder*, February 1983.

England, Breck. "Gospel Seeds in Scottish Soil." *Ensign*, February 1987.

Evans, Rory. "50 Romantic Wedding Venues in the U.S." *Brides*, January 21, 2013.

Goodwin's Weekly. "The Rotisserie Inn." June 26, 1915.

———. "Something Different: The Rotisserie Inn." September 18, 1915.

News of the Church. "Church Sells McCune Mansion." *Ensign*, May 2013.

Stocking, Russell. "Andrus Half Way House." *Andrus Recorder*, February 1983.

Newspapers

Benson, Lee. "About Utah: Take a Tour with Utah's Not-So-Secret Free Masons." *Deseret News*, Sunday, April 24, 2011. Accessed June 6, 2013.

Boal, Jed. "Salt Lake History Comes Alive at Stunning McCune Mansion." *Salt Lake Tribune*, December 17, 2010.

Deseret Evening News. "Robber of the Dead." May 27, 1893.

Groutage, Hillary. "New Look for Landmark." *Salt Lake Tribune*, November 15, 2001.

Hogsten, Leah. "McCune Mansion in Salt Lake Named Romantic Wedding Venue." *Salt Lake Tribune*, April 22, 2013.

Irvine, Arnold. "Memories of When the Devereaux Was Home." *Deseret News*, 1978.

Logan Republican. "Firemen Nearly Meet with Death in Burning Theatre." January 30, 1912.

Moore, Carrie A. "Holy Cross Trained Nurses, Built Interfaith Bonds." *Deseret News*, Saturday, June 14, 2008. Accessed August 11, 2013.

Press Club of Salt Lake City. "Dr. E.D. Woodruff." Men of Affairs in the State of Utah: A Newspaper Reference Work. Princeton University, 1914, digitized April 30, 2010. Accessed August 16, 2013.

Salt Lake Herald. "A Gruesome Tale." April 2, 1893.

———. "Jacob Moritz Dies at German Resort." June 10, 1910.

Salt Lake Telegram. "Men Who Have Made Utah Famous." August 29, 1906.

———. "Shubert Theatre Burned." January 26, 1912.

Salt Lake Tribune. "D.A.R.G. vs. U.P." November 24, 1883.

Spangler, Jerry. "McCartheys: Carrying the Torch." *Deseret News*, June 12, 2001.

Wells, Laura Y. "Letter to the Editor." *Salt Lake Tribune*, January 23, 1977.

Wolf, Colin. "Ghosts? No, but the City & County Building Is Scary as Hell." *City Weekly*, July 13, 2012.

Personal Interviews

Briggs, Todd. Security guard at Triad Center. 2003.

Chris, chef at McCune Mansion, tour guest. October 2004.

Conway, Bill. Security guard at City-County Building. October 2005.

Elliot, Garrick, Susan, Earl and Bill. Salt Lake Regional Medical Center employees. August 2007.

Fairclough, Larry. Tour guest and former grand master at Masonic temple. August 14, 2009.

Salt Lake City residents, business owners, managers, security guards, maintenance crews, curators and patrons of Story Tours: Ogden and Salt Lake City Ghost Tours. Collection of interviews, 2002–18.

Summer, employee at Inn on the Hill. Personal tour and interview. September 2007.

Tanner, Martin. July 2004.

Workers at Chart House Restaurant. 2004.

Websites

Alta Club. "Our Building." www.altaclub.org/Default.aspx?p=DynamicModule&pageid=386320&ssid=305748&vnf=1.

Bagley, Will. "Third Governor of Utah Was Run Out after Three Weeks." *Salt Lake Tribune*, December 30, 2001. Utah History to Go. historytogo. utah.gov/salt_lake_tribune/history_matters/123001.html.

Balls, Jami. "History of Fort Douglas." Utah History to Go. Accessed March 2017. historytogo.utah.gov/places/olympic_locations/historyoffortdouglas. html.

Catholic Diocese of Salt Lake City. "History of the Diocese." Accessed August 6, 2013. dioslc.org/about-us/mission-and-history.

Embry, Jessie. "Holy Cross Assn. Meets in Salt Lake City." *Intermountain Catholic*. Added April 25, 2008. Accessed August 16, 2013. www.icatholic. org/article/holy-cross-history-assn-meets-in-salt-lake-city-2012758.

FamilySearch Community Trees. "Edward Day Woodruff." The Church of Jesus Christ of Latter-day Saints, 2011. Accessed August 6, 2013. histfam. familysearch.org/getperson. php?personID=I509168&tree=earyutah.

Fort Douglas Military Museum. Accessed September 2002. www.fortdouglas. org.

Harris, Ja Nell. "Jane Lancaster Munday Andrus." Find a Grave. Added April 22, 2002. Accessed June 20, 2013. www.findagrave.com/ memorial/6363958/jane-lancaster-andrus.

Hauntedhouses.com. "McCune Mansion." 2006. Accessed May 19, 2013. www.hauntedhouses.com/states/ut/mccune_mansion.htm.

Historic Fort Douglas at the University of Utah. "A Brief History of Fort Douglas." web.utah.edu/facilities/fd/history/history.html.

"A History of Moroni Clawson." Submitted by Neil Clawson. Accessed December 3, 2005. www.mosesclawson.com/showdocument (site discontinued).

Inn on the Hill Bed and Breakfast. The McCarthey family, 2004. Accessed May 8, 2013. inn-on-the-hill.com.

Lord Mot. "Inn on the Hill, Salt Lake City, Utah." Waymarking, May 2011. Accessed August 16, 2013. www.waymarking.com/waymarks/ WMBEPH_Inn_on_the_Hill_Salt_Lake_City_Utah.

———. "The Woodruff-Riter-Stewart Mansion—Salt Lake City, Utah." Waymarking, May 12, 2011. Accessed August 6, 2013. www.waymarking. com/waymarks/WMBEVY_The_Woodruff_Riter_Stewart_Mansion_ Salt_Lake_City_Utah.

McCormick, John S. "Utah's Constitution Was Framed in City and County Building." Utah History to Go. Accessed August 8, 2013. historytogo. utah.gov/utah_chapters/statehood_and_the_progressive_era/ constitutionwasframedincityandcountybuilding.html.

Millennial Star. "Foreign Correspondence." February 25, 1855. The Official Site of the Milo Andrus Family Organization. Accessed August 8, 2013. miloandrus.org/category/milo-documents-and-articles/rulufandazuba. org/ original_docs/18550225-milos_duties_during_migration.pdf.

Mooney, Bernice M., and Miriam M. Murphy. "Sister Augusta and Catholic Education in Utah." *History Blazer*, June 1996. Utah History to Go. Accessed August 6, 2013. heritage.utah.gov/tag/sister-augusta-and-catholic-education-in-utah.

Mooroid. "Sisters of the Holy Cross–Salt Lake City, Utah." Waymarking, March 30, 2011. Accessed August 6, 2013. www.waymarking.com/ waymarks/WMB3C4_Sisters_of_the_Holy_Cross_Salt_Lake_City_ Utah.

Mormon Trails Association Inc. "Salt Lake City Cemetery." Accessed September 2002. www.mormontrails.org/Tours/Cemeteries/SLC/ citycem.htm.

Most Worshipful Grand Lodge of Free & Accepted Masons of Utah. "What Is Freemasonry? FAQ." July 27, 2012. Accessed June 6, 2013. utahgrandlodge.org/faq.php.

"National Register of Historic Places Inventory—Nomination Form: Alfred W. McCune Mansion." National Park Service. July 13, 1974. Accessed May 9, 2013. npgallery.nps.gov/GetAsset/b1881341-dcf4-40bb-9acb-5866ce979200.

Nichols, Jeffery D. "Colonel Connor Filled a Varied, Dramatic Role in Utah." *History Blazer*, May 1995. Utah History to Go. historytogo.utah.gov/utah_chapters/mining_and_railroads/ colonelconnorfilledavarieddramaticroleinutah.html.

The Official Site of the Milo Andrus Family Organization. "Milo Andrus Wives: Quick Facts.pdf." Added March 1, 2007. Accessed August 9, 2013. Miloandrus.org/category/milo-documents-and-articles.

Porebski, Lee. "Masonic Temple, Salt Lake City, Utah." Lee Porebski and Susan Burlison, September 2005. Accessed June 6, 2013. utahgrandlodge.org.

Preservation Utah. "Salt Lake City and County Building: Free Tours." Accessed August 8, 2013. preservationutah.org/experience/take-a-tour/ guided-tours/item/12-salt-lake-city-and-county-building.

Salt Lake Regional Medical Center. "History." Accessed July 13, 2013. saltlakeregional.org/history (site discontinued).

St. Louis Luminary. "Milo Andrus, 1814–1893—Autobiography." May 5, 1855. Accessed August 9, 2013. www.boap.org/LDS/Early-Saints/ MAndrus.html.

———. "The Point of Outfit for Our Spring Emigration." March 31, 1833, 74. The Official Site of the Milo Andrus Family Organization. Added December 28, 2006. Accessed August 9, 2013. www.miloandrus.org/st-louis-luminary.

Stocking, Russell. "From Our Kansas Correspondent." *The Mormon*, July 28, 1855. The Official Site of the Milo Andrus Family Organization. June 15, 2011. Accessed August 8, 2013. miloandrus.org/category/milo-documents-and-articles/.rulufandazuba.org/original_docs/18550708-milo_superhuman.pdf.

Strack, Don. "Railroads in Utah." Utah History Encyclopedia. Utah History to Go. Accessed June 2017. historytogo.utah.gov/utah_chapters/mining_and_railroads/railroadsinutah.html.

This Is the Place Heritage Park. "Andrus Halfway House and Farm." Accessed May 8, 2013. www.thisistheplace.org/heritage-village/buildings/andrus-halfway-house-and-farm.

Wikipedia. "Joe Hill." July 14, 2013. Accessed August 8, 2013. en.wikipedia.org/wiki/Joe_Hill.

———. "Martha Hughes Cannon." Accessed August 8, 2013. en.wikipedia.org/wiki/Martha_Hughes_Cannon.

Miscellaneous

Denver and Rio Grande Depot Tour. Utah State Historical Society file, Salt Lake City, Utah.

Holy Cross Hospital. "Inventory of the Holy Cross Hospital Records." Special Collections and Archives, 1875–1973, Collection number Accn 588, Boxes 1–7. University of Utah, J. Willard Marriott. Salt Lake City, Utah.

Stocking, Russell. "Half Way House." Sons of Utah Pioneers site 26. Temple Quarry Chapter, Sons of Utah Pioneers. Historical marker, Sandy, Utah. May 2013.

Utah State Historical Archives. "Historical Datasheet for Staines-Jennings Mansion, 'Devereaux.'" National Park Service. Accessed August 2017.

———. "National Register of Historic Places Inventory—Nomination Form: Devereaux House." National Park Service. December 28, 1970. Accessed August 2017.

ABOUT THE AUTHORS

L aurie Allen has been interested in ghost stories since she was a child hearing about the ghostly experiences in some of her family's homes. She has worked with Ogden and Salt Lake City Ghost Tours since its inception and loves wandering through cemeteries or interviewing others about their encounters with the supernatural. She is the author of *Mary's Monster*, a one-woman play about Mary Shelley, and enjoys storytelling in many forms, including writing, acting and telling in festivals, libraries and schools. Laurie has been teaching music in an elementary school for twenty-two years and feels strongly about keeping the arts available to children. She enjoys travel and learning about other cultures and has participated in a ghost tour in New Orleans, had a love aria sung to her outside the Parthenon in Rome, gone whale watching in Canada and ridden a gondola above the Swiss Alps.

C assie Howard-Ashton has been telling stories for over twenty-five years. She studied psychology and theater in college and found storytelling to be a natural fit in her career as a life and relationship coach. She also found writing and telling stories to be an essential part

of being a mother and important in her family life. Her children are grown, and now it is her grandchildren who ask for "just one more story." She happily grants them their wish.

Cassie has taught storytelling and writing workshops in K–12 schools, senior centers, summer camps for children and at national conferences. She has served as a local guild president, Utah State guild president and has worked as a committee chair for the Timpanogos Storytelling Festival in Utah for almost two decades now. She loves sharing the transformational power of story.

When she is not telling or teaching, she is helping families rewrite their own stories as a life and relationship coach. She has a private practice in her home, where she sees clients regularly.

She lives with her adorable and supportive husband and large family in Salt Lake City, Utah.

Kristen Clay has circled the globe as a storyteller, actor, teacher and perpetual student. She is the creator and director of Story Tours: Ogden and Salt Lake City Ghost Tours, Hysterical History Tours and custom storytelling concerts. She has been a featured teller at the Timpanogos Storytelling Festival and is a regular teller at the WSU Storytelling Festival. Kristen is well known for bringing the islands of Polynesia alive as she shares Hawaiian ghost stories (Obake tales), blending ancient mythology with modern phenomena. She also has a passion for healing and inspirational stories that she has been privileged to share in schools, prisons, rehab facilities and with youth-in-custody. Her greatest joy is watching her audiences and readers make connections with different cultures and experiences and then remember their own stories. Kristen currently resides in Utah. When not writing or performing, she enjoys traveling, reading, cooking, spending time in nature and hanging out with friends, family and her menagerie of pets.

Nannette Watts is an accomplished storyteller in many genres, yet her ghost story beginning was rocky. After telling stories on the Salt Lake City Ghost Tours for several years, she began to get comfortable with the ghosts there; one even followed her home. This did not lessen her lifelong fear of ghosts, which probably began the day she was born in the infamously haunted Queen of Angels hospital of Los Angeles. Knowing now that being oversensitive has a purpose, she looks for stories with ghosts.

Nannette earned a BFA in music, dance and theater from BYU and subsequently worked as a triple threat in Utah. She augmented her portfolio when she learned the trade of storytelling, becoming a *quadruple* threat and a creative powerhouse.

She has served a long and distinguished tenure on the Timpanogos Storytelling Committee, where she specializes in working with young students. She is the author of *Youth Tell* and a director of National Youth Storytelling, which seeks to build and promote youth tellers.

While still tied to her native California beaches at heart, she is content to live nestled beneath the shadows of tall mountains with her sweetheart and her children.

Visit us at
www.historypress.com